Italian
Renaissance
Drawings

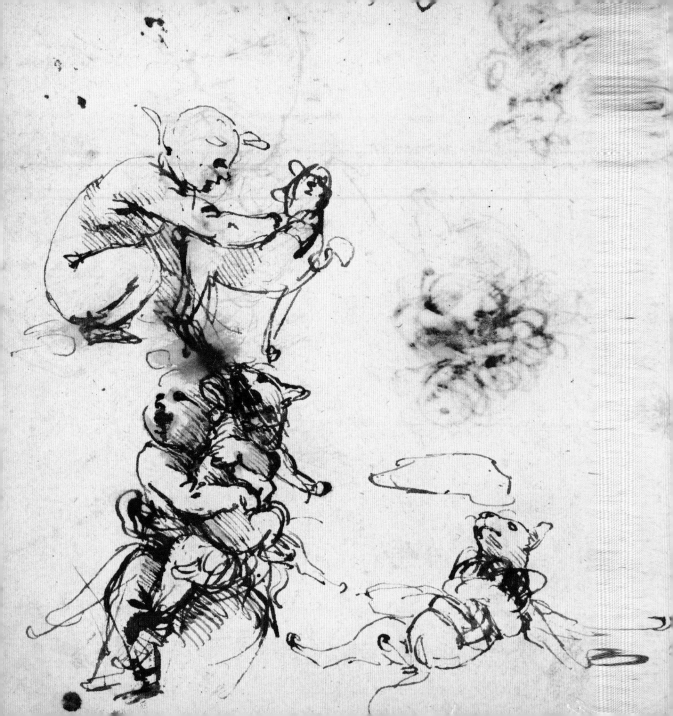

Italian Renaissance Drawings

HUGO CHAPMAN

THE BRITISH MUSEUM PRESS

© 2010 The Trustees of the British Museum

Hugo Chapman has asserted the right to be
identified as the author of this work.

First published in 2010 by the British Museum Press
A division of the British Museum Company Ltd
38 Russell Square, London WC1B 3QQ
www.britishmuseum.org

A catalogue record for this book is available
from the British Library.

ISBN 978-0-7141-2669-2

FRONTISPIECE Detail from Leonardo da Vinci's
Studies of the Infant Christ and a cat, c. 1478–8 (fig. 48, p. 89).
British Museum, London
OPPOSITE Detail from Michelangelo's *Head of a youth*,
c. 1508–1510 (fig. 20, p. 38). British Museum, London

Designed by Philip Lewis
Printed in Italy by Graphicom SRL, Verona

The papers used in this book are natural, recyclable
products made from wood grown in sustainable
forests. The manufacturing processes conform to the
environmental regulations of the country of origin.

CONTENTS

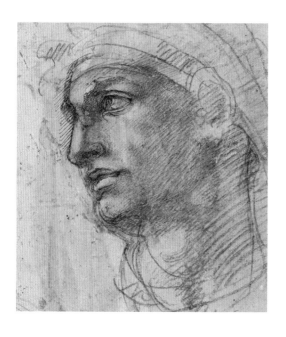

LOCATION OF ARTISTS

While the artists featured in this book sometimes moved from one
region to another throughout northern and central Italy, each region
had its own character. The artists have been listed below according to
the city or town with which they are most closely associated. Although
Italy was not a united country until the nineteenth century, one of the
legacies of Ancient Rome was that Italy shared a Latin-based language
that encouraged mobility. The intellectual and artistic renewal
inspired by the classical culture that underpins the Renaissance came
in widely different forms, a diversity reflecting the varied political and
social fabric of fifteenth-century Italy.

NORTHERN ITALIAN ARTISTS

Giovanni Antonio Boltraffio (Milan)
Jacopo de' Barbari (Venice)
Giovanni Battista Cima (Venice)
Jacopo and Gentile Bellini (Venice)
Vittore Carpaccio (Venice)
Giovannino de' Grassi (Milan)
Andrea Mantegna (Padua/Mantua)
Pisanello (Mantua/Verona)
Andrea Solario (Milan)
Titian (Venice)
Marco Zoppo (Padua/Venice)

CENTRAL ITALIAN ARTISTS

Fra Bartolommeo (Florence)
Sandro Botticelli (Florence)
Maso Finiguerra (Florence)
Domenico Ghirlandaio (Florence)
Benozzo Gozzoli (Florence)
Filippino Lippi (Florence)
Fra Filippo Lippi (Florence)
Michelangelo (Florence/Rome)
Perugino (Perugia/Florence)
Antonio Pollaiuolo (Florence/Rome)
Piero Pollaiuolo (Florence)
Raphael (Urbino/Rome)
Giuliano da Sangallo (Florence)
Luca Signorelli (Cortona)
Parri Spinelli (Arezzo)
Andrea del Verrocchio (Florence)
Leonardo da Vinci (Florence/Milan)

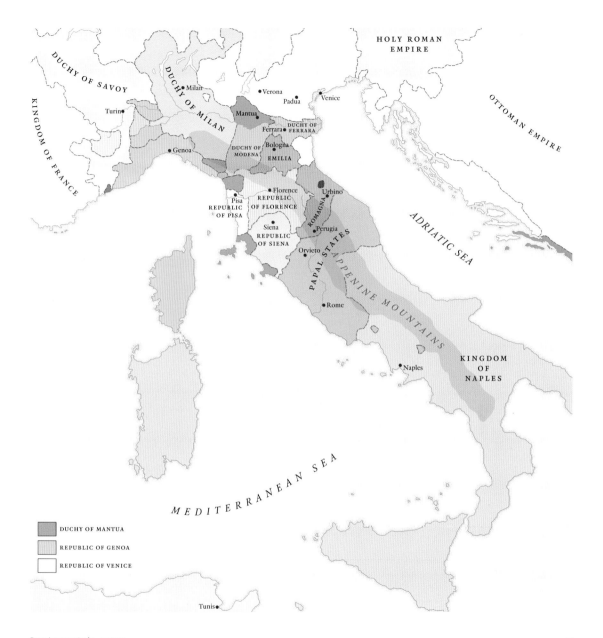

DUCHY OF SAVOY

DUCHY OF MILAN

HOLY ROMAN EMPIRE

KINGDOM OF FRANCE

OTTOMAN EMPIRE

Milan

Verona

Padua

Venice

Turin

Mantua

Ferrara

DUCHY OF FERRARA

Genoa

DUCHY OF MODENA

Bologna

EMILIA

Florence

Urbino

Pisa

REPUBLIC OF PISA

REPUBLIC OF FLORENCE

ROMAGNA

Perugia

ADRIATIC SEA

Siena

REPUBLIC OF SIENA

Orvieto

PAPAL STATES

APPENINE MOUNTAINS

Rome

Naples

KINGDOM OF NAPLES

MEDITERRANEAN SEA

DUCHY OF MANTUA

REPUBLIC OF GENOA

REPUBLIC OF VENICE

Tunis

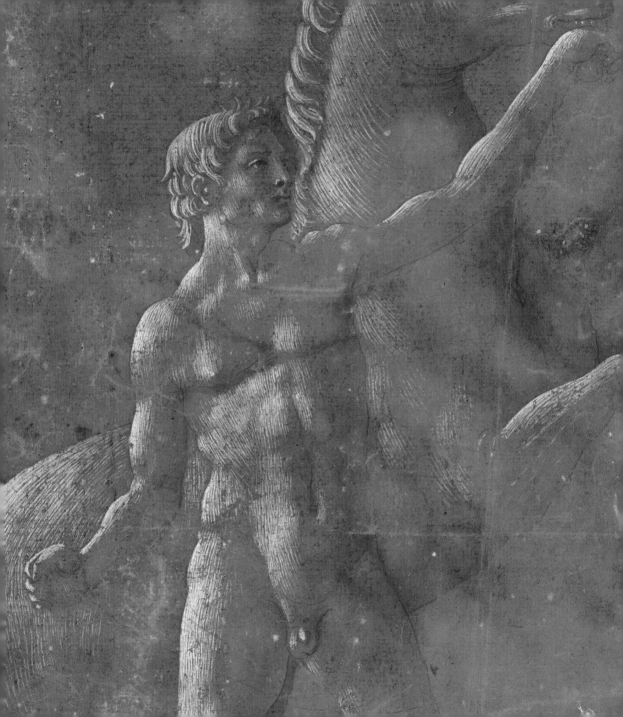

INTRODUCTION

THE CULTURAL AND INTELLECTUAL flowering known as the Renaissance, the French translation of the Italian word *rinascimento* or rebirth, developed in Italy in the 1400s before spreading north. It came about as Italy recovered from the unrest and depopulation caused by the bubonic plague's arrival from the east in 1348. Italy's prosperity, based on trade and banking, and the relative political stability of the varied city states and principalities, provided a favourable environment for rulers and the mercantile elite, as well as the scholars and artists who served them, to explore the culture, philosophy and politics of the antique civilizations of Greece and Rome more deeply.

In the artistic sphere the study of classical sculpture, such as by the Florentine Benozzo Gozzoli (fig. 1), encouraged greater naturalism in the depiction of the human body. The equilibrium between naturalism and idealization achieved in the early 1500s by artists such Raphael (see pp. 26–8, 78–81) was reached after prolonged investigation by previous generations. Admiration for the ancient world did not shake the religious underpinning of Italy, with the church acting as a spiritual and temporal power. For artists such as the devout Michelangelo the beauty of the idealized male body was a reflection of God's perfection.

A reverence for the beauty of the natural world also inspired artists to depict it more faithfully (see pp. 83–94), for example, in the landscape drawing by the Florentine polymath Leonardo da Vinci (fig. 2). Leonardo may have inspired his younger Florentine contemporary, Fra Bartolommeo to take up landscape drawing. Fra Bartolommeo's drawing demonstrates his interest in the human element of landscape, such as the travellers walking along a path towards the village (fig. 3).

2
Detail of Leonardo's **Landscape**, (fig. 47, pp. 86–7)

3
FRA BARTOLOMMEO
(1472–1519)
Wooded ravine, bridge and travellers leading up a hill,
c. 1495–1508
Pen and brown ink, 21.5 × 28.8 cm
British Museum, London
(1957,1129.66)

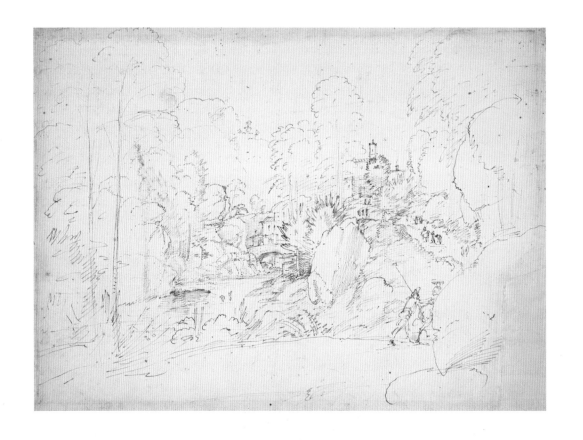

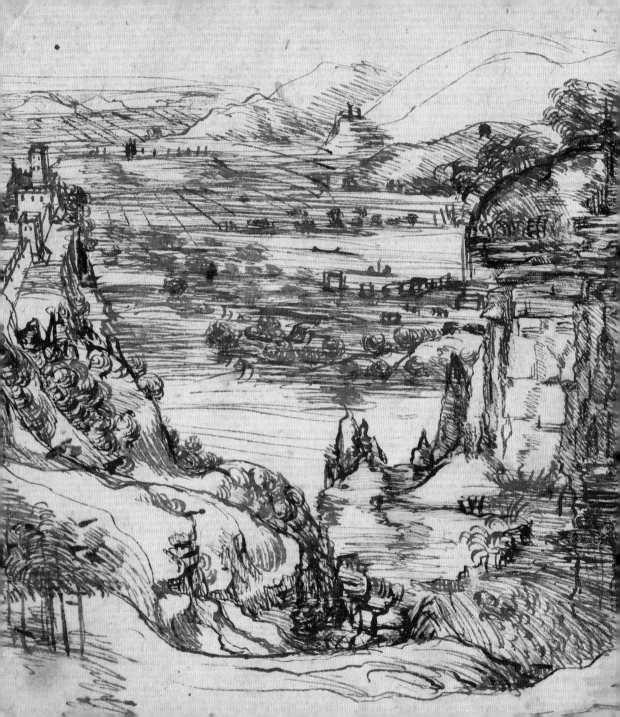

The interaction between Renaissance and classical art was creative and dynamic. Renaissance artists emulated lost antique paintings described in written texts, like the allegory of the struggle between Vice and Virtue drawn by the Paduan artist Andrea Mantegna (fig. 4). The drawing is entitled *Virtus Combusta* (Virtue in flames), a reference to the burning laurel branches at the feet of the corpulent figure of Ignorance, flanked by Avarice and Ingratitude. On the left mankind, represented by a blind women, is led to a precipice by Lust playing a pipe, Deceit with his head covered by a sack and ass-eared Error.

4
Andrea Mantegna (1430/31 –1506)
Virtus Combusta, c. 1490–1506
Leadpoint (?), pen and brown ink, coloured wash with a black over red background.
British Museum, London (Pp, 1.23)

Opposite:
Detail of fig. 4 showing the seated Ignorance.

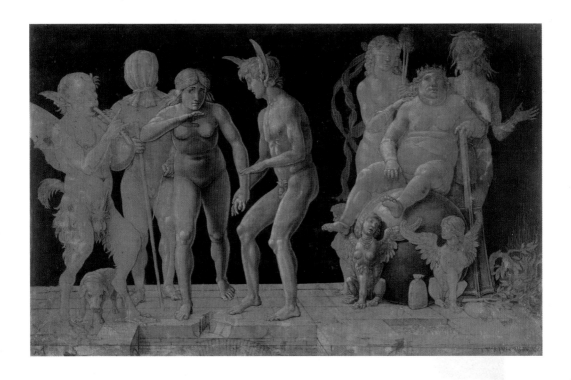

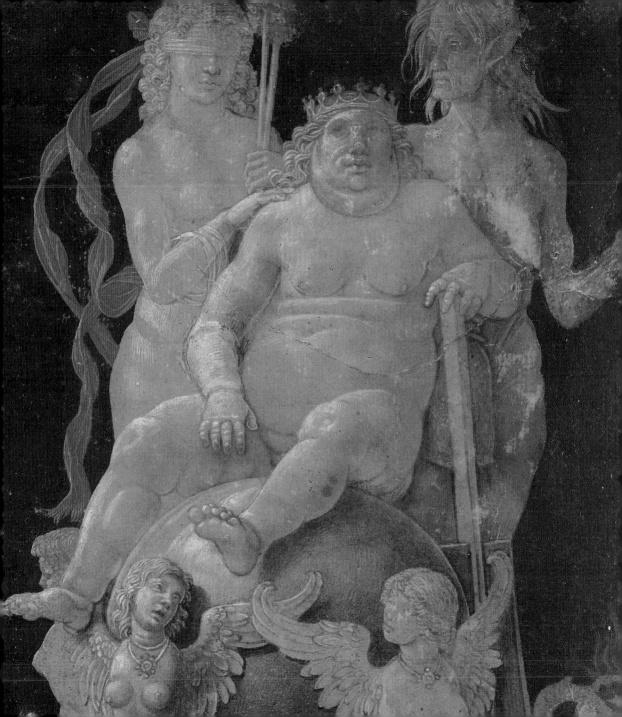

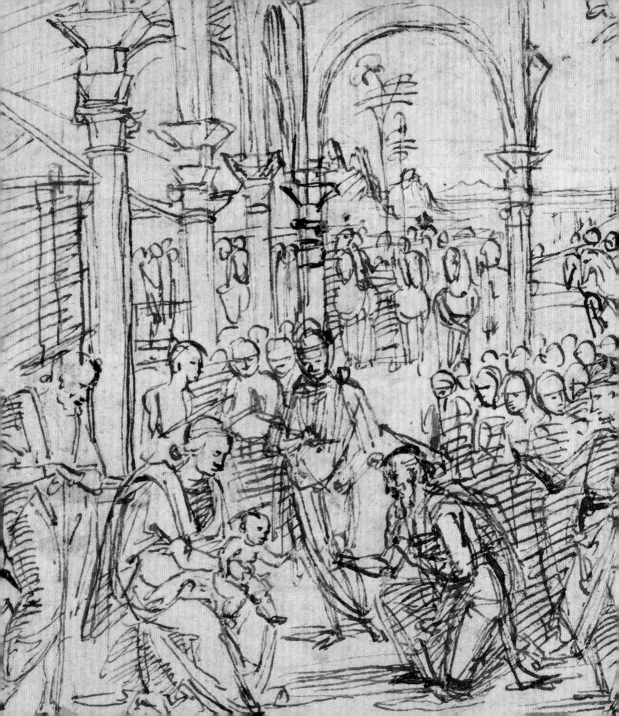

A competitive edge pushed artists to be innovative, most notably in the formulation of perspective in the early 1400s in Florence. This regulated the recession of figures and buildings in space, thereby strengthening the connection between real and pictorial space as seen in Perugino's *Adoration of the Magi* (fig. 5). Spatial manipulation added a new dimension for Renaissance artists making their pictorial story telling more vivid. The illusion of three-dimensional space also required painters to master the representation of light (see pp. 30–31).

The practice of drawing was essential to realizing these innovations. The widening availability of paper, a trend accelerated by the introduction of the printing press from Germany in the mid-1460s, was fundamental because previously artists relied on durable, but expensive vellum (treated animal skins). Italy's regional character is reflected in the diverse approaches and techniques favoured by artists in their drawings. While a few drawings were made as finished works of art (for example, see p. 76), the majority were working studies for a variety of finished works, ranging from altarpieces to weapons (fig. 6).

Some of the themes that characterize Renaissance art are brought together in the following pages, the selection gives an idea of the vital role drawing played in how artists' thought and worked.

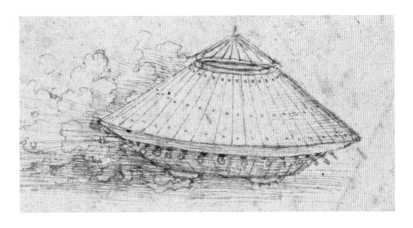

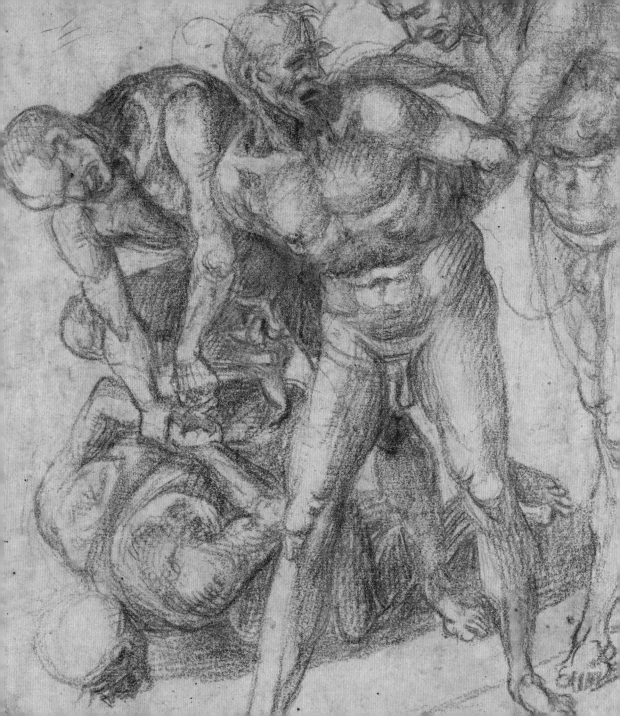

MOVEMENT

*All the movements of the body should
be closely observed by the painter.*

LEON BATTISTA ALBERTI
On Painting, 1435–6

THE TREATISE ON PAINTING by the Florentine architect
and scholar Leon Battista Alberti (1404–72), written first in Latin
and then in Italian, stresses the vital importance for painters to
include figures in action. Although it is uncertain how widely Alberti's
manuscript circulated, dynamic movement became one of the defining
features of Renaissance art.

One of the first artists noted for his ability to represent figures
in motion was the Florentine Antonio Pollaiuolo, his skill honed in
drawings, such as in his pen study for a lost painting of *Hercules and the
Hydra* (fig. 7). Pollaiuolo's main activity was as a bronze sculptor, and
his familiarity in thinking three dimensionally comes through in the
drawing's bold pose and clear outlines. A similar use of drapery to
convey bodily movement is employed in a highly expressive study by
the Florentine architect Giuliano da Sangallo (fig. 8).

The purpose of Sangallo's large-scale study is unknown, but for
most artists studying movement was linked to preparing paintings as
is the case with those by the Florentine Domenico Ghirlandaio (fig. 9)
and his Tuscan contemporary Luca Signorelli (fig. 11).

Detail of Signorelli's **Four nudes
in combat** (fig. 10, p. 23)

7

ANTONIO POLLAIUOLO
(c. 1432–98)
Hercules and the Hydra c. 1460
Pen and brown ink,
24 × 16.9 cm
British Museum, London (T, 11.8)

A study for a lost large-scale
canvas executed by Antonio and
his brother Piero for the Palazzo
Medici in Florence. In this rapid
pen drawing, he concentrated on
studying the emphatic forward
motion of the classical hero
towards the snake-headed
monster on the right.

8

GIULIANO GIAMBERTI,
called GIULIANO DA SANGALLO
(*c.* 1445–1516)
Standing man tearing a scroll
c. 1485
Black chalk, pen and brown ink,
brown wash, heightened with
lead white, 39.4 × 27.4 cm
Gabinetto Disegni e Stampe
degli Uffizi, Florence (155 F)

The drawing may depict the
Roman poet Lucretius who was
said to have been driven mad by
drinking a love potion. The sense
of the subject's disturbed state
of mind is vividly conveyed by
the agitated motion of his hair
and drapery.

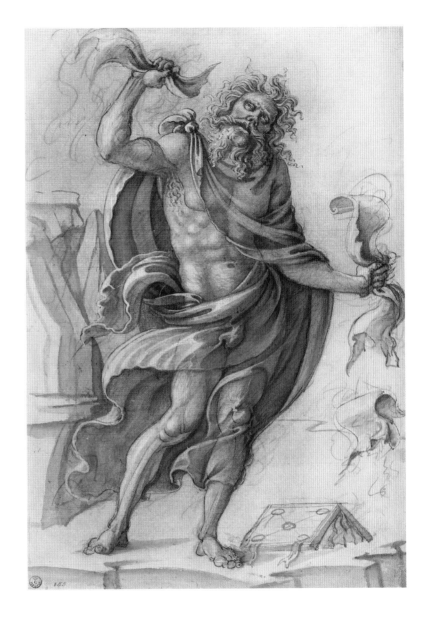

9
DOMENICO BIGORDI, called
DOMENICO GHIRLANDAIO
(1448/9–94)
A woman pouring water
from a jug
c. 1486–90
Pen and brown ink, 21.9 × 16.8 cm
Gabinetto Disegni e Stampe
degli Uffizi, Florence (289 E)

Drawings demonstrate the care and attention that Renaissance artists lavished on draperies which were important not only in giving a sense of the shape of the body beneath, but also as a means of showing motion. Ghirlandaio's study for a servant pouring water into a basin is related to a figure on the right side of his *Birth of the Virgin* fresco in a chapel in S. Maria Novella, Florence. The woman's fluttering skirts inject a note of dynamism in an otherwise rather static composition. Her body is reduced to simplified geometrical forms, with the undulating drapery described through a gridwork of pen lines and the blank paper deployed as a highlight.

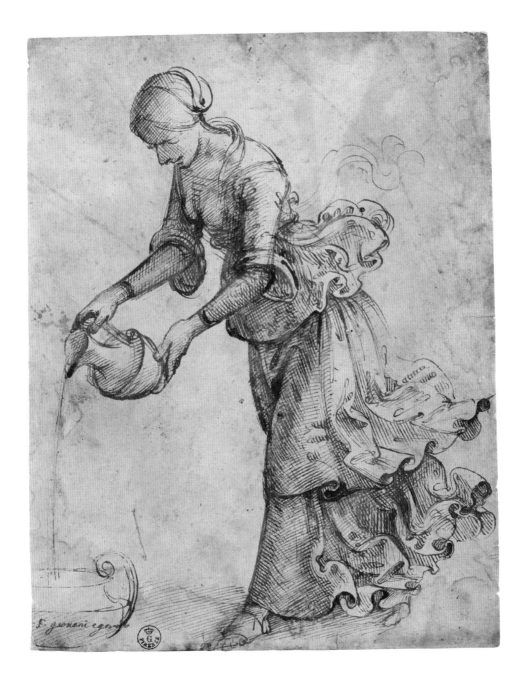

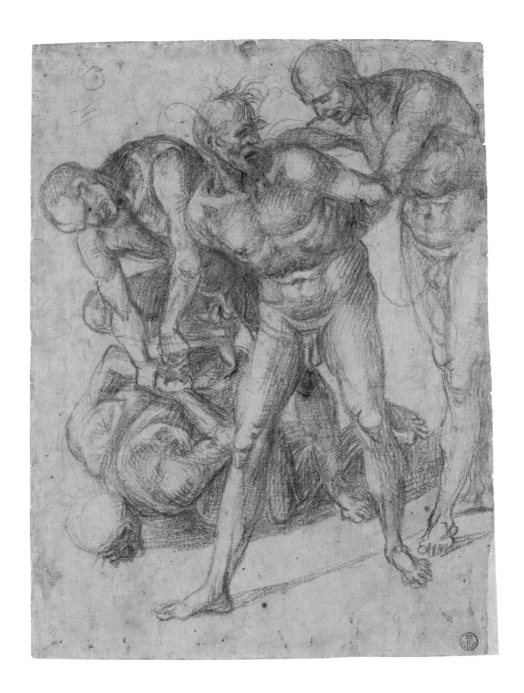

10

LUCA SIGNORELLI
(c. 1450–1523)
Four nudes in combat
c. 1500
Black and red chalk,
28.6 × 21.5 cm
Gabinetto Disegni e Stampe
degli Uffizi, Florence (1246 E)

This is most likely a rejected idea for a group of figures in one of Signorelli's *Last Judgement* scenes painted for a chapel in Orvieto Cathedral. The Tuscan painter was famous for depicting male nudes in violent movement, a skill seen in the expressive pose of the man pressed downwards by the devil on his back.

Ghirlandaio's use of cross-hatching to emphasize solid form is also found in the drawing of his Tuscan contemporary Luca Signorelli (fig. 10), and even more strongly in studies by Ghirlandaio's erstwhile pupil Michelangelo. The gesturing figure by Michelangelo (fig. 11), perhaps related to the unrealized *Battle of Cascina* fresco for the Palazzo Vecchio in Florence, is inspired by the famous classical marble in the Vatican, the *Apollo Belvedere*. Michelangelo changed the balanced poise of the sculpture to one of unstable motion. The favoured medium for drawing figures in dynamic poses was pen, its flexible and responsive nib ideally suited to kinetic abbreviations of form favoured by Michelangelo and Raphael (figs 11–13).

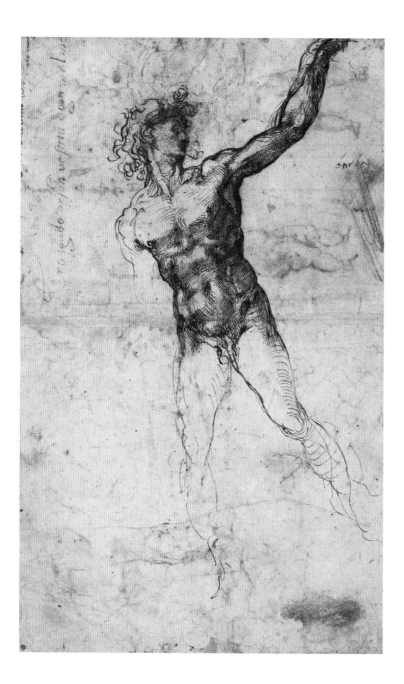

11

MICHELANGELO (1475–1564)
**Recto: A youth beckoning;
a right leg**
c. 1504
Pen and two shades of brown ink;
black chalk (leg study),
37.4 × 22.8 cm
British Museum, London
(1887,0502.117)

For Michelangelo the male torso
was the key expressive area of
the body. It was there that the
movement and torsion of the
figure was conveyed through the
alignment of the shoulders and hips.
His description of the muscles in
the abdomen is intensely sensual,
the direction of the hatching
mapping the surface of the body.

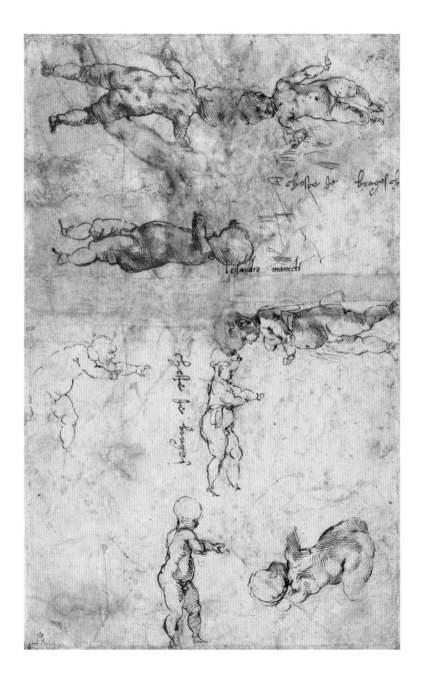

12
Verso: Eight studies of nude children; a woman in profile
c. 1504
Leadpoint, some gone over in pen and brown ink; the Virgin and Child in black chalk (?)
British Museum, London
(1887,0502.117)

The children in this study are related to Michelangelo's circular marble relief known as the *Taddei Tondo*, now in the Royal Academy of Arts, London. Michelangelo's muscular Christ Child and Infant Baptist are far removed from the naturalistic children in Leonardo's drawings (see fig. 48, p. 88).

13
RAPHAEL (1483–1520)
Studies of the Virgin and Child
c. 1506–7
Pen and brown ink, over traces
of red chalk, 25. 3 × 18.3 cm
British Museum, London (Ff, 1.36)

Raphael's stream of variation of poses for Virgin and Child
paintings exemplify how artists were able to imagine seamlessly
the movement and interaction of figures. They were able to do so
through long practice of life drawing, like the study of two almost
nude models executed in metalpoint by the Florentine Filippino
Lippi (fig. 15). The specific description of the two figures in Lippi's
drawing (perhaps the same model studied twice) contrasts with
the simplified abstraction of Raphael's Virgin and Child sketches. The
Umbrian painter's gift for seeing the geometrical forms underlying
the human body can also be appreciated in his study for the group of
figures around Christ's body related to his painting *The Entombment*,
now in the Villa Borghese in Rome (fig. 14). The dense cross-hatching
in the study shows Raphael's debt to Michelangelo's pen drawings.

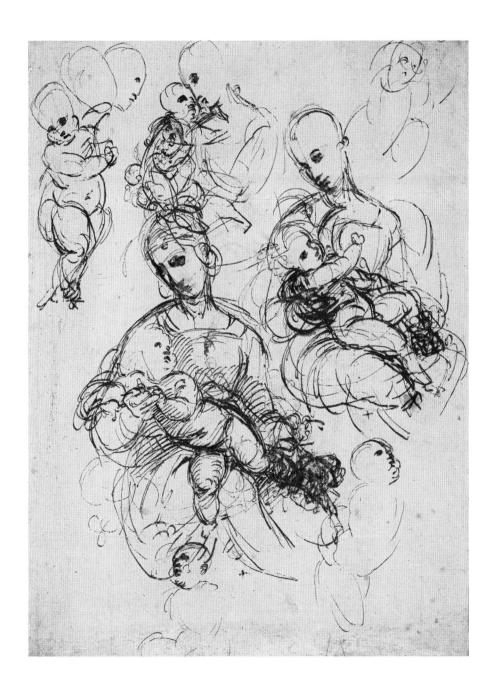

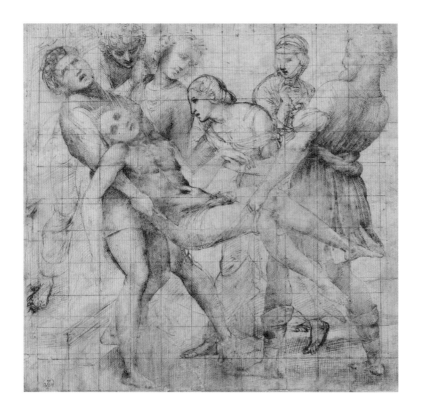

14
RAPHAEL (1483–1520)
The Entombment
c. 1506
Pen and ink, over black chalk, squared in stylus and red chalk, and then pen and ink, the head and right shoulder of the leftmost bearer pricked for transfer, 29 × 29.7 cm
Gabinetto Disegni e Stampe degli Uffizi, Florence (538 E)

The commission to paint an altarpiece for a church in Perugia gave the young Raphael the chance to demonstrate his grasp of the new dynamic style he had learned in Florence. This study for the main group in the work is squared in stylus and red chalk to allow the figures to be scaled up to the larger size of the painting. For an earlier drawing of the same work, see fig. 44, p. 81.

15

FILIPPINO LIPPI (c. 1457–1504)
Two male nudes
c. 1485–8
Silverpoint left figure and
leadpoint right figure, heightened
with lead white, over stylus, on
grey prepared ground,
25.9 × 18.5 cm
British Museum, London
(1858,0724.4)

Lippi's use of two different metal-
points indicates that the drawing
was made in two stages. Lippi did
his best to link the figures, with
the figure on the right craning to
look at the drawing or letter on his
companion's knee.

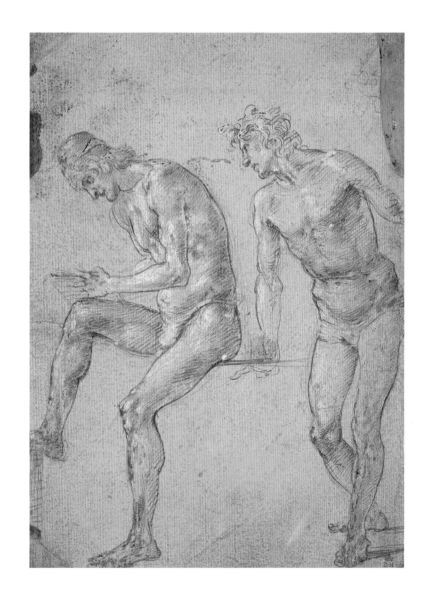

LIGHT

Shadows and lights are the most certain means by which the shape of any body comes to be known.

LEONARDO DA VINCI
Notes from his unfinished treatise on painting

NO PAINTER BEFORE LEONARDO had studied light with such rigour, his interest in it extending to optics, the anatomy of the eye, the atmospheric effects of moisture-filled air in landscapes and many other related topics. Such research went far beyond what was practically required, yet Leonardo's sustained study was distilled in his own work in the complex manipulation of light to unify the scene, to focus attention on particular details and to create atmosphere.

Leonardo's early drawing of a *Bust of a warrior* (fig. 16) is a virtuoso display of lighting executed in silverpoint (see the glossary on p. 96). Leonardo achieved the subtle shifts in lighting solely by minute changes to the density of the parallel hatching. Leonardo's sensitivity to lighting was shaped by his training with the Florentine sculptor Andrea del Verrocchio. The latter's deployment of light in his study of a woman's head for volume and texture was instrumental for his pupil's development (fig. 17).

Detail of Carpaccio's **The Vision of St Augustine** (fig. 21, p. 40)

16

LEONARDO DA VINCI
(1452–1519)
Bust of a warrior
c. 1475–1480
Silverpoint, on a cream
prepared ground, 28.7 × 21.1 cm
British Museum, London
(1895,0915.474)

The drawing is inspired by
a lost bronze or silver relief by
Leonardo's master, Andrea del
Verrocchio. Leonardo makes the
invention his own in naturalistic
touches, such as the leathery
wings of the dragon on the helmet
and the snarling lion on the
breastplate that hints at the
warrior's ferocity. The detail
opposite shows how Leonardo
uses the cream ground as a
highlight to convey the fall of
light from the left.

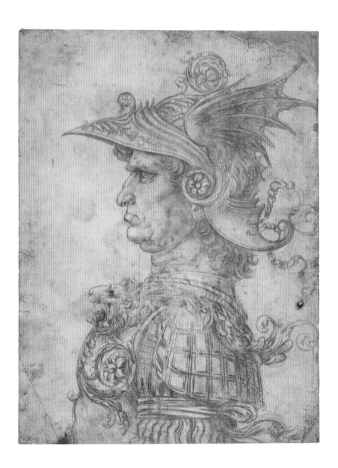

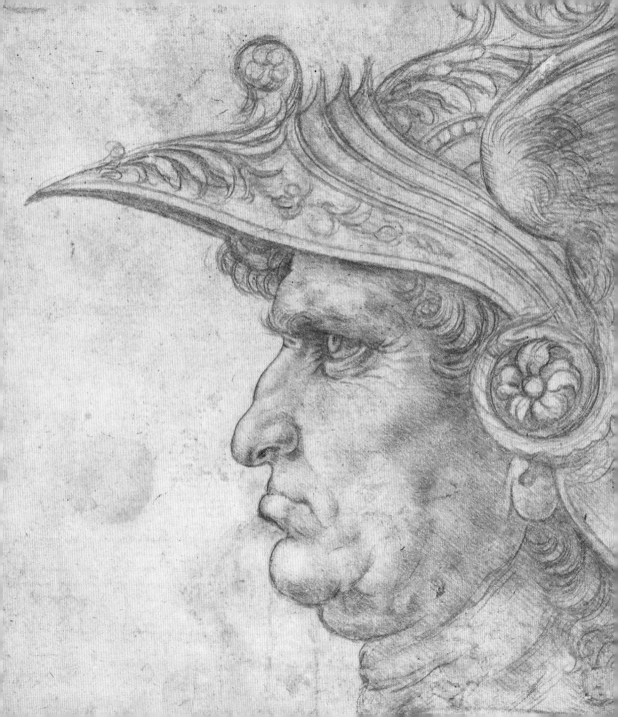

17
ANDREA DEL VERROCCHIO
(1435–88)
Recto: Head of a woman
c. 1475
Charcoal (some oiled ?),
heightened with lead white,
pen and brown ink
on the left eye, 32.4 × 27.3 cm

18
Verso: Head of a woman
c. 1475
Charcoal (some oiled ?),
heightened with lead white,
pen and brown ink
on the left eye, 32.4 × 27.3 cm
British Museum, London
(1895,0915.785)

Verrocchio probably began by
sketching from life the head of
the woman leaning her head on
her hand on the verso. This spare
charcoal drawing was the basis for
the much more elaborate drawing
on the other side (fig. 17). The
Florentine's sculptural interests
can be felt in the use of light to
model the form, the softness of
charcoal allowing him to blend the
tones with his fingers. The
woman's pensive downcast gaze
could serve equally well as a model
for a Virgin, or for a mythological
figure like a nymph.

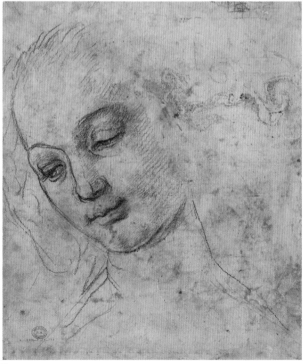

Verso

Recto

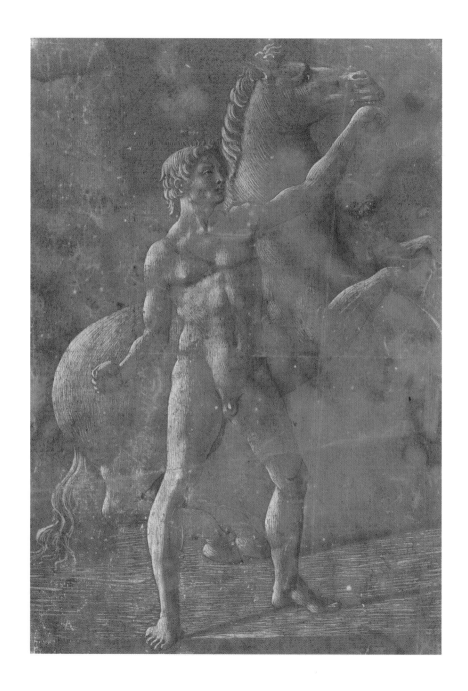

19
Attributed to BENOZZO DI LESE,
called BENOZZO GOZZOLI
(c. 1420–97)
A nude man with a horse
c. 1447–9
Silverpoint, grey-black wash,
heightened with lead white, on
blue preparation, 35.9 × 24.6 cm
British Museum, London (Pp, 1.18)

The relief-like quality of Leonardo's drawing highlights the importance of studying sculpture when analysing light. An early example is the free adaption by Gozzoli of one of the gigantic classical marble *Horse tamers* on the Quirinal Hill in Rome (fig. 19). The Florentine painter gave the classical group a naturalistic twist by reducing the size of the male figure so that he is smaller than his rearing steed. The sensual glorification of the beauty of the naked male form in classical sculptures was an important stimulus for Renaissance artist to begin to draw from life. Classical sculpture often provided the only means for artists to study the female form since moral and religious precepts meant that drawing from nude female models was unthinkable.

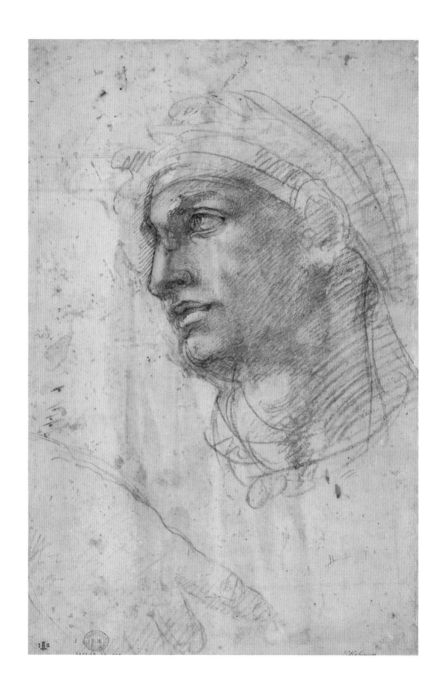

20

MICHELANGELO (1475–1564)
**Verso: Head of a youth
and a right hand**
c. 1508–1510
Black and red chalk, pen and
brown ink, over stylus (head);
black chalk (hand), 31.1 × 21.4 cm
British Museum, London
(1895,0915.498)

The study exemplifies the
sculptor's parsimony in his use of
paper as it was drawn on the other
side of a study dating from the
1490s. As the head can be dated
on stylistic grounds to the period
of Michelangelo's work in the
Sistine Chapel in Rome, it signifies
that he went through his stock
of drawings to find one with an
unused verso.

Michelangelo was an equally keen student of classical sculpture and
its influence is apparent in his idealized head of a young man (fig. 20).
The three-dimensional volume of the study is achieved predominantly
though hatching in black chalk over outlines in red chalk.

A more atmospheric approach was shown in drawings by artists
from Venice shaped by the ever-shifting patterns of light, air and water
in the city's lagoon setting. In a study by Carpaccio for a painting of *The
Vision of St Augustine* (fig. 21), the main subject is a heavenly burst of light,
the interior illuminated predominantly by wash rather than contour.

Titian combined black and white chalk to sensuous effect in
imparting a sense of soft light bathing the rounded flesh of the young
woman in one of the rare drawings by the Venetian artist (fig. 22).

21

VITTORE CARPACCIO
(?1460/6–1525/6)
The Vision of St Augustine
c. 1501–8
Pen and brown ink, brown-grey
wash, over leadpoint and stylus
27.8. × 42.6 cm
British Museum, London
(1934,1208.1)

This is a finished drawing for the
canvas still located in its original
setting, the Scuola di San Giorgio
degli Schiavoni in Venice (the
headquarters of the religious
confraternity of the Dalmatian
community). The painting differs
little from the drawing except
for the replacement of the
ermine with a dog looking up
at St Augustine.

TITIAN (c. 1490–1576)

Portrait of a young woman

c. 1510–15

Black and white chalk, on faded
blue paper, 41.8 × 26.5 cm
Gabinetto Disegni e Stampe
degli Uffizi, Florence (718 E)

Few drawings by Titian survive,
but from the evidence of this
study he was as skilled with chalk
as he was in oils. He adeptly
focuses attention in this study on
the woman's features by progres-
sively making his description of
her costume less detailed.

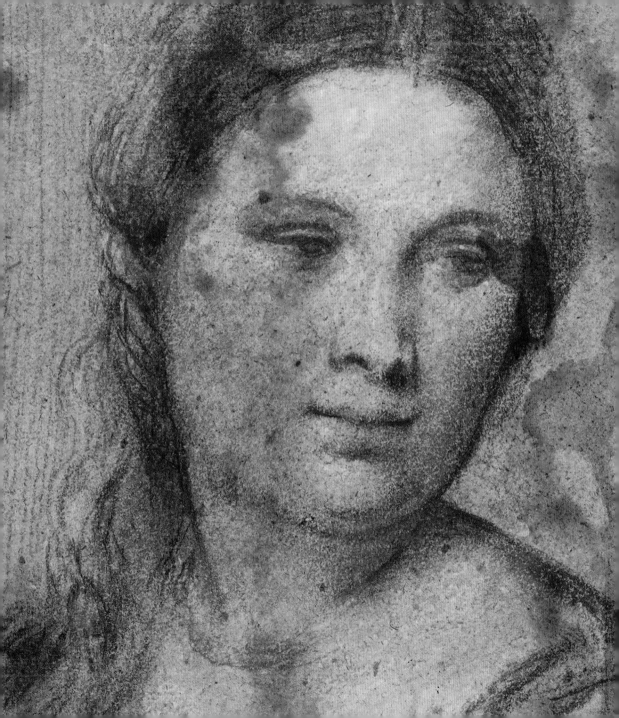

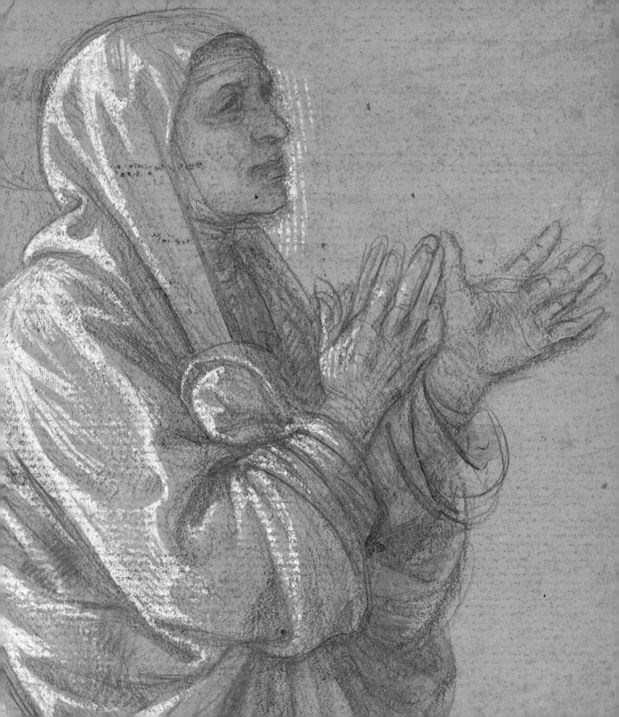

THE HUMAN FIGURE

Observe and contemplate the positions and actions of men in talking, quarrelling, laughing and fighting together … record these with rapid notations in this manner in a little notebook which you should always carry with you.

LEONARDO DA VINCI
Notes from his unfinished treatise on painting

THE RENAISSANCE AMBITION to create art that stimulated empathy required artists to create figures whose naturalism of movement and expression struck a chord with the viewer. Life drawing, almost invariably from male models or classical sculptures for reasons of decorum, was instrumental in attaining this goal. Observational drawing, as recommended by Leonardo, had been pioneered by artists in the first half of the fifteenth century like the northern Italian court artist Pisanello (fig. 23). The neat precision of his unflinching depiction of corpses indicates that it is most likely a neat copy made after a sketch. For the Florentine Filippo Lippi, father of Filippino, life drawing allowed him to imagine a gesture of the hands that expressed the Virgin's maternal suffering as she watched Christ's crucifixion (opposite and fig. 24).

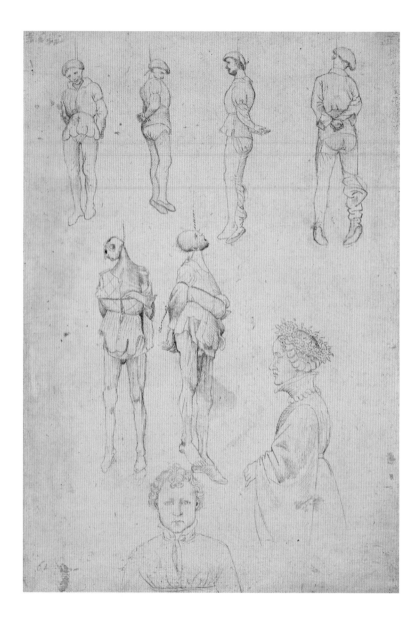

23
ANTONIO DI PUCCIO PISANO,
called PISANELLO (c. 1394–1455)
**Studies of hanged men,
a woman and a child**
c. 1434–8
Pen and brown ink, over leadpoint,
28.3 × 19.3 cm
British Museum, London
(1895,0915.441)

Although at first glance Pisanello
appears to have studied two
gently rotating bodies on a gibbet,
closer attention reveals that each
of them is slightly differentiated
through changes in their costume.

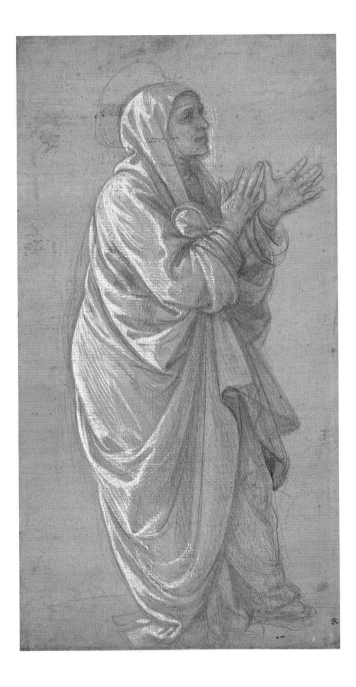

24
FRA FILIPPO LIPPI (*c.* 1406–69)
A standing woman
c. 1460–69
Silverpoint and black chalk,
with brown wash, heightened
with lead white, over stylus,
on pink prepared ground,
30.7 × 16.6 cm
British Museum, London
(1895,0915.442)

The woman's upward look and
anguished gesture suggest that
the drawing is a study for the
sorrowful Virgin Mary at the foot
of the cross in a Crucifixion. The
drawing does not correspond to
any painting by Lippi, but on
stylistic grounds it can be dated
to the end of his career.

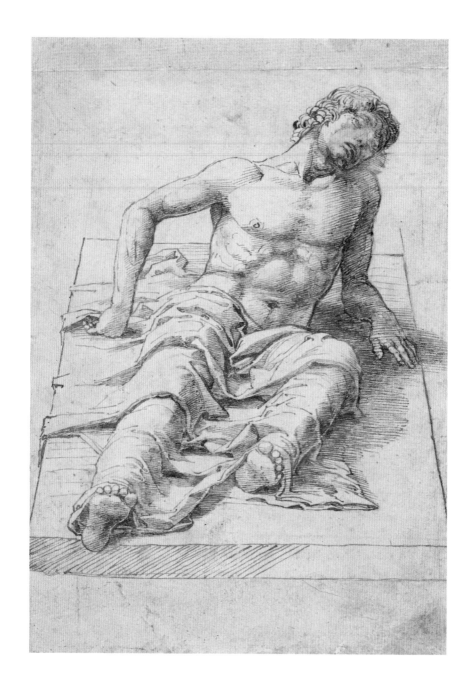

25
ANDREA MANTEGNA
(1430/1–1506)
Man lying on a stone slab
c. 1475–85
Black chalk or charcoal,
pen and brown ink, over incised
ruled lines for sides of the slab,
20.3 × 13.9 cm
British Museum, London
(1860,0616.63)

Lippi's silverpoint study was probably not made from a model, yet his inventive fluency is proof that he must have made drawings of this kind, which are now lost. The same is true of Mantegna who was able to imagine a foreshortened male figure, perhaps Lazarus miraculously raised from the dead (fig. 25). The idea of placing the viewer at the foot of the bier looking down at a reclining body is one that Mantegna used in his famous painting of the *Dead Christ* in the Pinacoteca di Brera in Milan. The sense of life returning to the stiffened limbs of Lazarus is expressed through his angular pose. The ridges and depressions of the folds of the drapery arranged around his lower body take on the aspect of a vast panoramic landscape, akin to that studied by Leonardo at much the same period (see fig. 47, pp. 86–7).

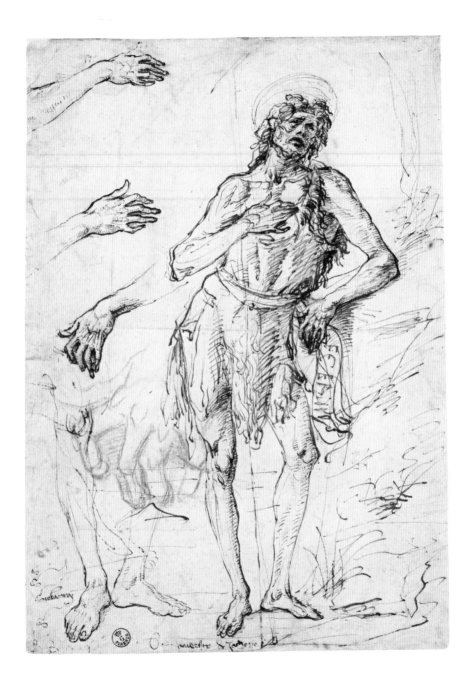

ANTONIO POLLAIUOLO
(c. 1432–98)
**St John the Baptist in
the wilderness**
?1470s
Pen and brown ink, one of
the studies of the left hand
of the saint in black chalk,
27.9 × 19.4 cm
Gabinetto Disegni e Stampe
degli Uffizi, Florence (699 E)

This cannot be related to a
surviving work by the Florentine
artist, although the desert setting,
evoked by the rocky cavern and
scrubby plants, suggests that it
was a study for a painting. With
great economy Pollaiuolo captures
the fervour and suffering of the
Baptist as he awaits the arrival
of Christ.

Mantegna's engraver-like precision in defining the musculature in pen contrasts with the speed with which Pollaiuolo used it to draw *St John the Baptist in the wilderness* (fig. 26). Pollaiuolo's experimentation with differing positions for the hands and feet give a sense of how carefully he calibrated the pose. Pollaiuolo's wiry figure shows a basic anatomical knowledge, yet it was not until Leonardo in the 1490s that artists began to dissect corpses to gain a deeper understanding of the body (fig. 27).

Leonardo's younger rival, Michelangelo, also studied flayed bodies, his understanding of anatomy allowing him to manipulate the male body for expressive effect while retaining the semblance of naturalism (fig. 28).

27
LEONARDO DA VINCI
(1452–1519)
**Abdomen and left leg
of a nude man**
c. 1506–10
Red chalk on orange-red
prepared paper, 25.2 × 19.8 cm
Inscribed by the artist, writing
right to left, which translates
as '…/the fat is in the hollows,
the lean in the relief (?)'
British Museum, London
(1886,0609.41)

Leonardo's understanding of the
underlying muscular structure
of the male leg in this drawing
derives from his dissection of
bodies. He was almost certainly
the first artist to pursue his
interest in the workings of the
body to such lengths.

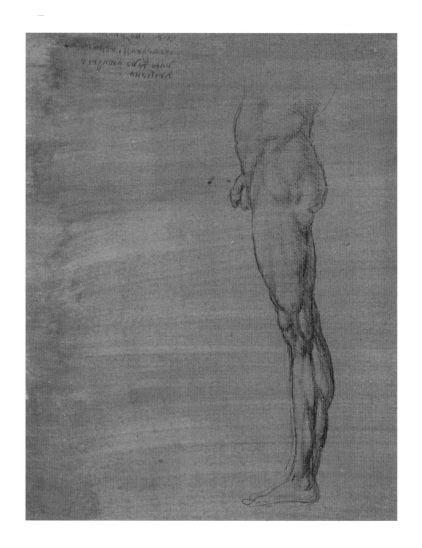

28
MICHELANGELO (1475–1564)
**A group of three nude men;
the Virgin and Child**
c. 1503–4
Black chalk (nude men);
pen and brown ink over leadpoint
(Virgin and Child), 31.5 × 27.7 cm
British Museum, London
(1859, 0625.564)

The black chalk figures were
probably intended for the back-
ground of Michelangelo's abortive
Battle of Cascina fresco planned
for the Palazzo Vecchio in Florence.
The pose of the figure being lifted
up, perhaps a Florentine soldier
alerting his companions of the
advancing Pisans, is studied in
a related pen drawing (see fig. 11,
p. 24). On the right is an early study
for the *Bruges Madonna*, a marble
sculpture that Michelangelo
carved for a church in the Flemish
town. He sketched a male figure
as a model for the seated Virgin.

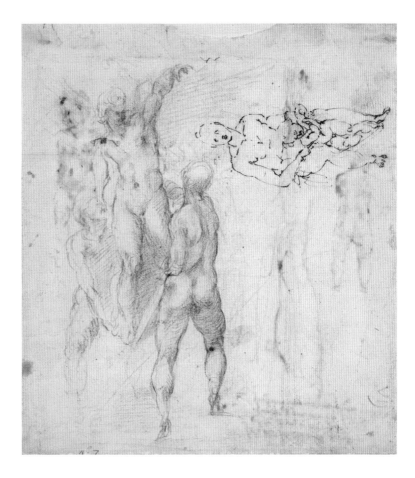

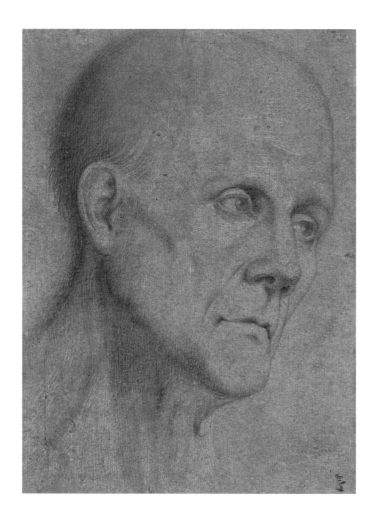

29
ALVISE VIVARINI
(1442/53–1503/5)
Head of an elderly man
c. 1485–95
Brush drawing in brown wash,
heightened with lead white,
over black chalk, on blue-grey
paper, 21.3 × 15.6 cm
British Museum, London
(1876,1209.619)

As was often the case in Venice,
the Vivarini were a dynasty of
artists with Alvise following in the
footsteps of his father and uncle.
The ascetic features of this head
would make it a suitable model
for an aged saint, although it
cannot be matched precisely
with a figure in one of Vivarini's
surviving paintings.

Venetian artists were more inclined to describe the body through
the effect of light and colour on its surface, as seen in the tonal
contrast of wash and white heightening on blue paper employed
by Alvise Vivarini (fig. 29) and Carpaccio (fig. 30).

30

VITTORE CARPACCIO
(?1460/6–1525/6)
Head of a middle-aged man
c. 1510–20
Brush and brown ink, heightened
with lead white, over black chalk,
on blue paper, 26.7 × 18.7 cm
British Museum, London
(1892,0411.1)

Carpaccio's speciality as a painter
was large-scale canvases for
Venetian religious confraternities
known as *scuole*. Such works
often contained numerous figures
in contemporary Venetian dress
witnessing the central narrative,
and the present drawing is most
likely a study for such a work.
Over a black chalk underdrawing,
Carpaccio loosely brushed in with
brown wash and lead white the
light and shade that describe the
shape and textures.

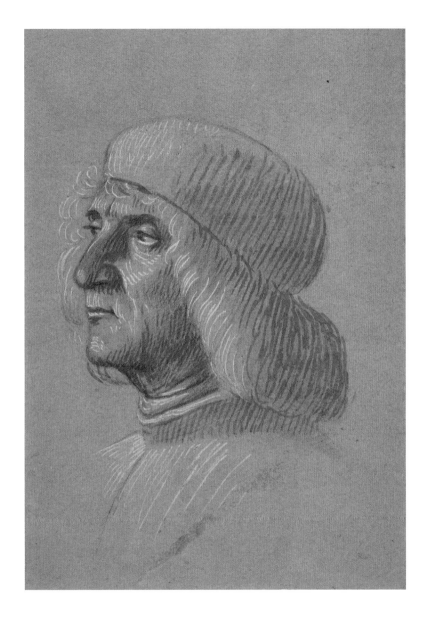

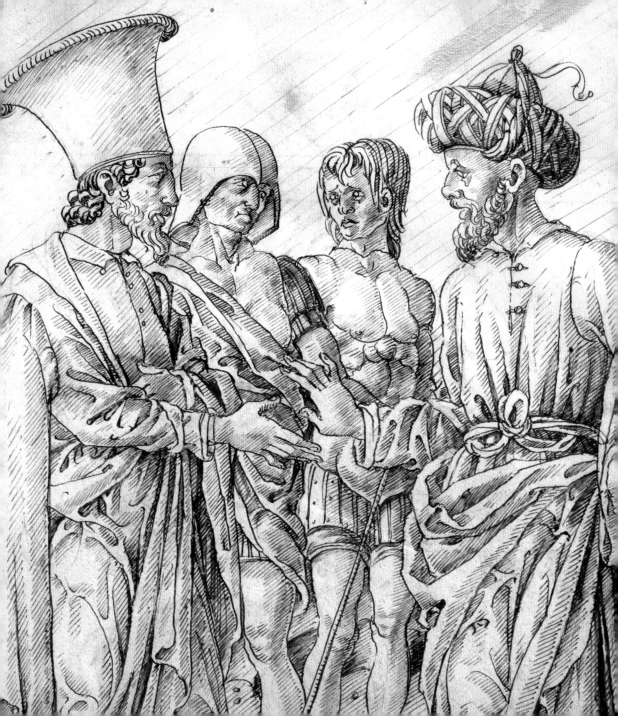

COSTUME
AND DRAPERY

Branches twist themselves now up, now down,
now away, now near, the parts contorting
themselves like ropes. Folds act in the same way,
emerging like the branches from the trunk of a tree.

LEON BATTISTA ALBERTI
On Painting, 1435–6

DRAPERIES IN RENAISSANCE PAINTINGS are details that
most modern viewers skate over, yet the evidence of drawings show
the careful preparation that artists devoted to them. They were
essential to give a sense of the position of the underlying limbs in
order that the viewer had a clear idea of a figure's pose. Draperies
could also be used to direct the eye around a figure to emphasize the
illusion of its sculptural three-dimensionality. The fluttering motion
of drapery folds was key to how painters introduced movement in
their works, and signalled to the viewer the direction in which the
figures were moving. Draperies could also subtly reinforce the
emotional and psychological states of the protagonists in paintings.
The fashion-conscious Italian audience, especially in a country where
the cloth trade was so important, was also sensitive to the cut and
material of painted draperies so that artists needed to take care in
their depiction.

Detail of Zoppo's **Four men in**
a rocky landscape (fig. 34, p. 61)

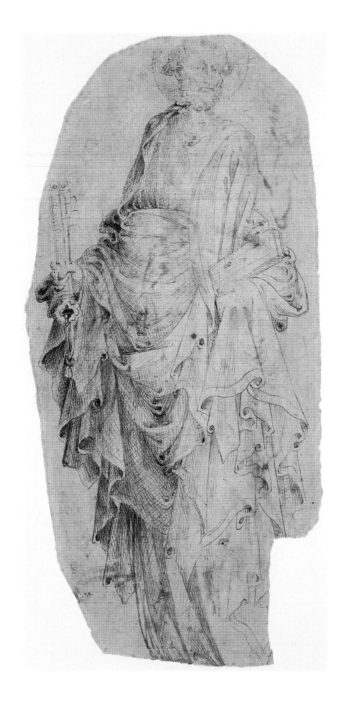

31
PARRI SPINELLI (1387–1453)
St Peter holding a key
c. 1435–45
Pen and brown ink, 27.4 × 13 cm
British Museum, London
(1895,0915.480)

Spinelli is little known as a painter
but his pen drawings survive in
relatively large numbers. He was
born and worked in Arezzo, the
home town of the Italian painter
and writer Giorgio Vasari, author
of the *Lives of the Artists* (1550
and 1568). Patriotic pride explains
Spinelli's fulsome biography in
Vasari's work, the key text for
Italian Renaissance art.

32, 33
GENTILE BELLINI (? 1429–1507)
**A Turkish janissary; and a
woman in Middle Eastern
costume** (ILLUSTRATED OVERLEAF)
c. 1480
Pen and blackish brown ink, the
outlines of the woman indented,
21.5 × 17.5 cm and 21.4 × 17.6 cm
British Museum, London
(Pp, 1.19 and Pp, 1.20)

Bellini does not appear to have
utilized these costume studies in
his work, although their circulation
among artists is verified by the
appearance of the janissary figure
in a fresco in the Vatican by the
Umbrian painter, Bernardino
Pintoricchio.

For the Gothic Tuscan painter Parri Spinelli, the pattern of folds
complement the graceful arch of St Peter's body (fig. 31). Spinelli is
not concerned to use the folds to give volume to his representation
of the elongated saint, instead they animate the surface with their
curling waves across his body. Also in pen the Venetian painter
Gentile Bellini minutely detailed the exotic costumes of a Turkish
soldier and a woman seen in Istanbul in 1479–81 (figs 32–3). Both
are record drawings, with colour notes of the woman's clothes, such as
rosso (red) on the turban, for future reference. Bellini was clearly
conscious that his first-hand experience of eastern costumes would
provide him with valuable material for future paintings, hence these
careful drawings.

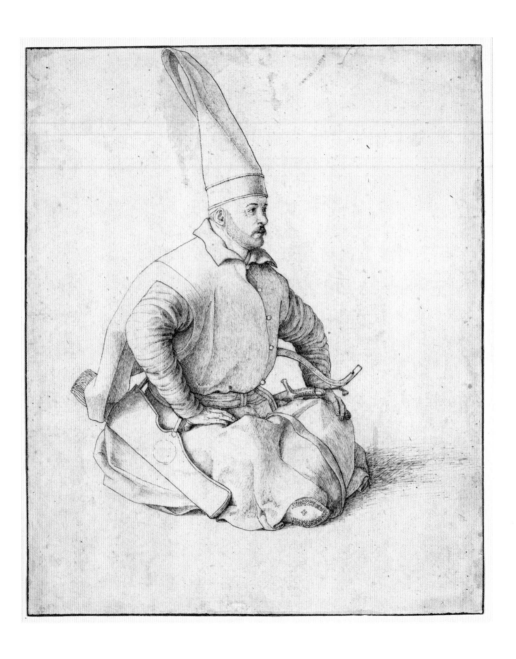

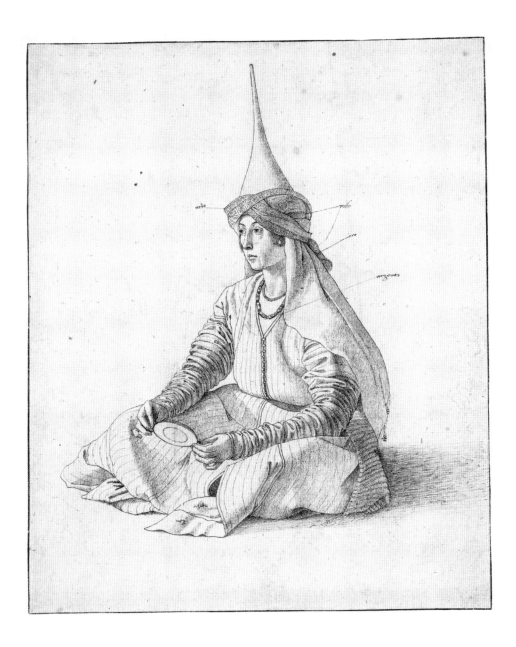

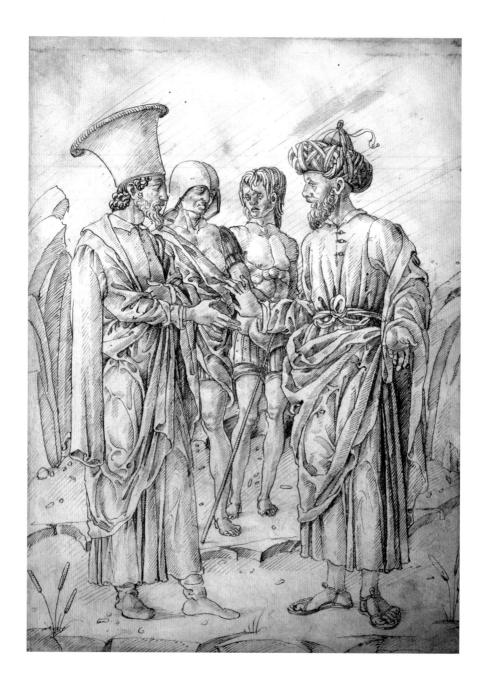

34
MARCO ZOPPO (c. 1432–78),
Four men in a rocky landscape,
a page from the **Rosebery album**, c. 1455–65
Pen and brown ink on vellum,
21.8 × 15.8 cm
British Museum, London
(1920,0214.1.4)

A comparable attentiveness to fashion detail is shown by the Paduan-trained Marco Zoppo (fig. 34) whose chief influence in his formation was Andrea Mantegna. The drawing comes from an album of finished studies on vellum that was clearly commissioned by a specific patron in north Italy. It depicts a Byzantine in a tall cylindrical hat talking to a turbanned easterner, watched by two soldiers dressed in classical costume. The drawing does not appear to have a narrative, but it invites the viewer to guess what the topic of conversation might be between these two exotic figures. Zoppo's album of drawings is one of handful made in the period 1450–70 as luxury works of art. This category of work was ended by the advent of engraving, introduced from Germany in the 1460s, that enabled artists to use their design skills to make images that could be widely reproduced.

35

GIOVANNI ANTONIO
BOLTRAFFIO (c. 1467–1516)
**Study of a drapery for
the Risen Christ**
c. 1491
Silverpoint, heightened with
lead white, over black chalk,
on blue prepared ground,
18 × 15.5 cm
British Museum, London
(1895,0915.485)

Boltraffio is recorded as a pupil
of Leonardo in Milan, and the
technique and style of this
drawing are modelled on the
teachings of his Florentine master.

The drapery studies of the Milanese Giovanni Antonio Boltraffio
(fig. 35) and Fra Bartolommeo (fig. 36) are both preparatory for
paintings, and in their different ways inspired by Leonardo. Boltraffio
was his Milanese pupil and the choice of medium and the strong
contrasts of lighting are strongly Leonardesque. Fra Bartolommeo
chose to study comparable lighting effects with the drapery arranged
on a wooden mannequin. His study is executed in brush and distemper
(an aqueous paint containing animal glue) on linen in emulation of
studies by the young Leonardo. Painters also looked to classical sculpture
for inspiration, in the case of the Venetian Giovanni Battista Cima,
the clinging folds of Hellenistic marbles (fig. 37).

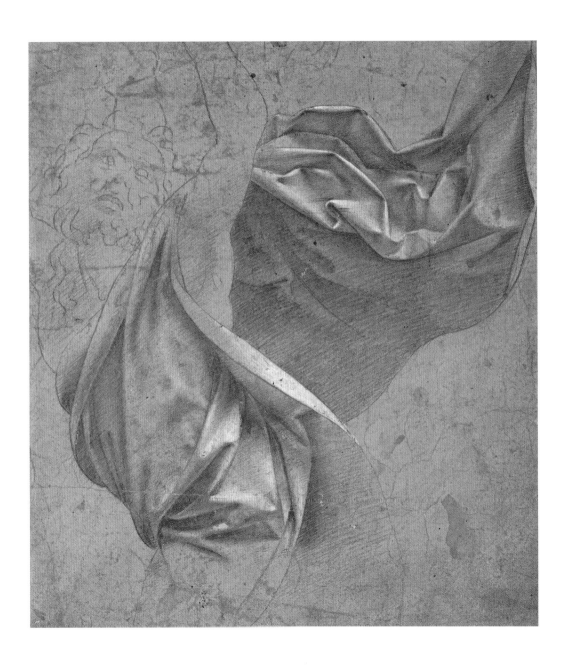

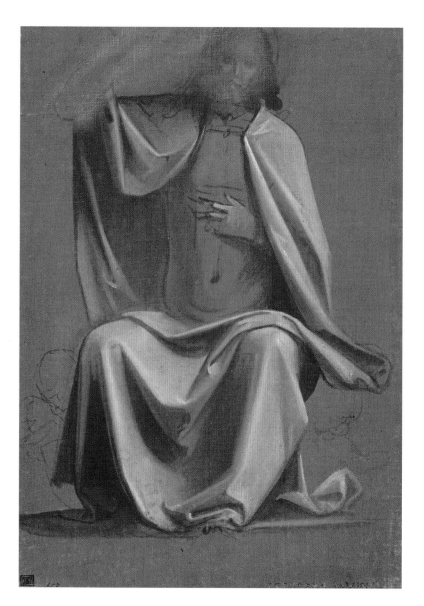

36
BARTOLOMMEO DI PAOLO,
called BACCIO DELLA PORTA
or FRA BARTOLOMMEO
(1472–1517)
**Drapery for a figure of
Christ in Judgement**
c. 1500
Brush drawing in grey-brown
and white distemper on linen
with a dark grey prepared ground,
30.5 × 21.2 cm
British Museum, London
(1895,0915.487)

The practice of making drapery
studies in watery paints on linen
was pioneered in Verrocchio's
studio in the 1470s, and was taken
up by his pupil Leonardo, who in
turn strongly influenced Fra
Bartolommeo. The iconic stillness
and majesty of Christ judging
mankind at the end of the world
is magnified by the stiff folds of
his drapery.

37

GIOVANNI BATTISTA CIMA
(c. 1459/60–1517/18)
Christ as Saviour of the World
(**Salvator Mundi**)
c. 1490–1500
Brush and green and grey-brown
wash, heightened with lead white,
over some stylus around the head,
on blue paper, 39.5 × 19.2 cm
British Museum, London
(1895,0915.803)

The clinging folds of drapery
that plaster the limbs of Christ
are inspired by classical Greek
sculpture. Venetian painters had
access to such works because
they were imported into the city
through the Republic's trading
links with Greece and Turkey.

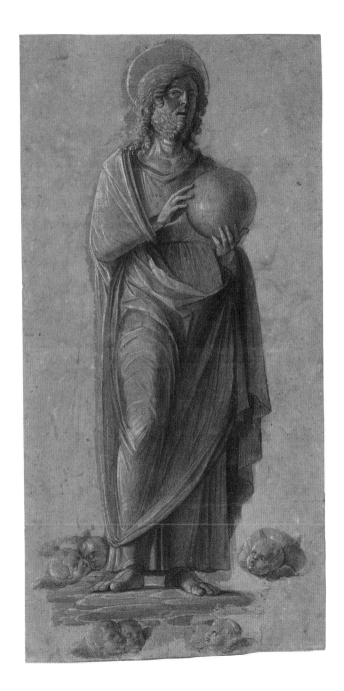

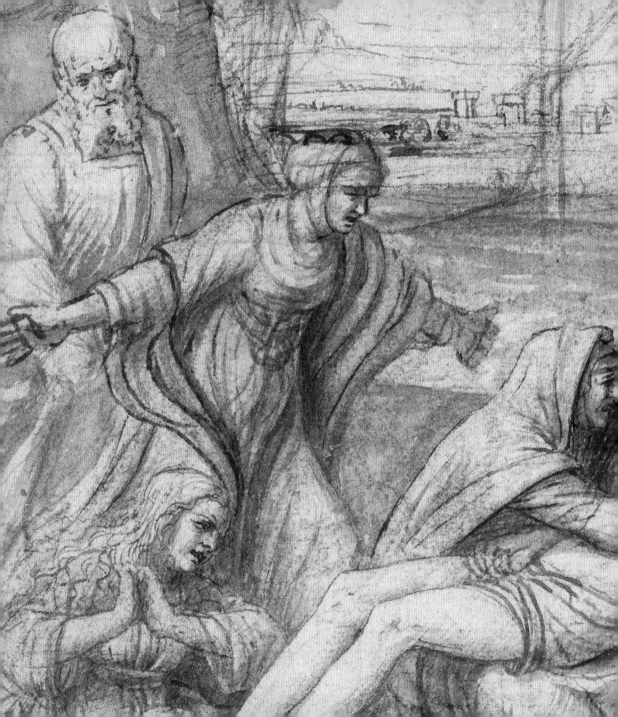

STORY TELLING

*The esteem in which painting has been held has always
been great … it requires the representation not only
of the face or countenance and the lineaments of the
whole body, but also, and far more, of its interior feelings
and emotions, so that the picture may seem to be alive
and sentient and somehow move and have action.*

BARTOLOMEO FACIO
On illustrious men, 1456

THE EMOTIVE, EMPATHETIC STYLE of painting recommended
by classical scholars, such as Alberti and Facio (*c.* 1410–57), gradually
became a reality during the fifthteenth century. Artists planned
their designs on paper to achieve affective and original narratives
in their paintings.

Perspective was a new tool to structure the composition, its use
exemplified in a pen drawing by the Umbrian Pietro Perugino
(fig. 38). Filippo Lippi's study was drawn at comparable design stage
as the artist sought ways of articulating the crowd's astonished
reaction at Drusiana's resurrection (fig. 39). The fine adjustments of
gesture and pose in the charcoal study by the Tuscan Luca Signorelli
denote that it was done at the end of the preparatory process (fig. 40).
The ruled squaring allowed the figures to be enlarged by copying the
contents of each square to a bigger grid.

Detail of Solario's **Lamentation**
(fig. 41, p. 75)

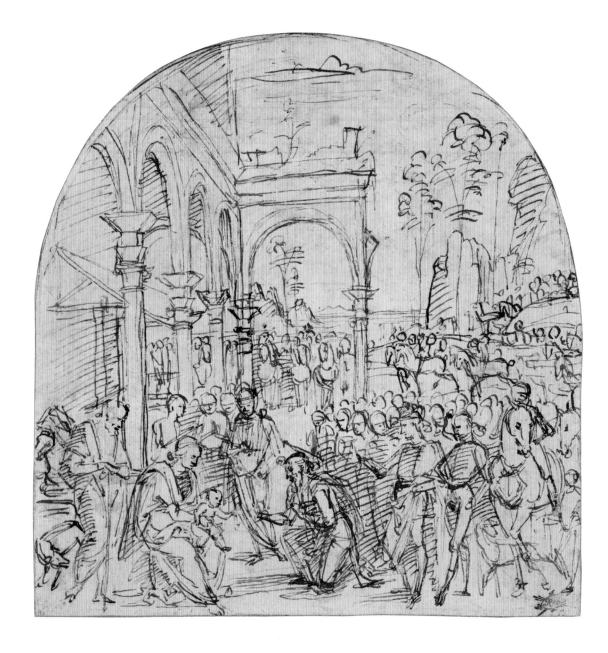

38
PIETRO VANNUCCI,
called PERUGINO
(c. 1450–1523)
Adoration of the Magi
c. 1480–90
Leadpoint, pen and brown ink,
19.2 × 18.2 cm
British Museum, London
(1853,1008.1)

Perugino's drawing is a study for a lost fresco painted in the 1480s for a cloister of the convent of S. Giusto alle Mura in Florence. The architecture of the cloister may have prompted the Umbrian painter, whose links with Florence were through his training in Andrea del Verrocchio's studio, to introduce an arcade along the left side of the design. The architectural motif is cleverly used by Perugino to pull the eye back into space, while at the same time the columns supporting the arches provide a clear idea of the position of the figures in space. Perugino's experience can be felt in his confident handling of perspective and the rapid pace with which he sketches the animated scene.

39

FILIPPINO LIPPI

(1457–1504)

Studies for the Resurrection of Drusiana

c. 1496

Black chalk, pen and brown ink,
brown wash, over stylus,
29 × 23.8 cm
Gabinetto Disegni e Stampe
degli Uffizi, Florence (186 E)

Lippi's drawing is an early idea for
the fresco in the Strozzi chapel in
the Florentine church of S. Maria
Novella. The subject of St John
the Evangelist restoring to life
an elderly widow, Drusiana, was
an appropriate one for a chapel
in which his patron, the wealthy
Florentine banker Filippo Strozzi,
was to be buried. The shock
caused by the resurrection
ripples through the bystanders
in Lippi's drawing.

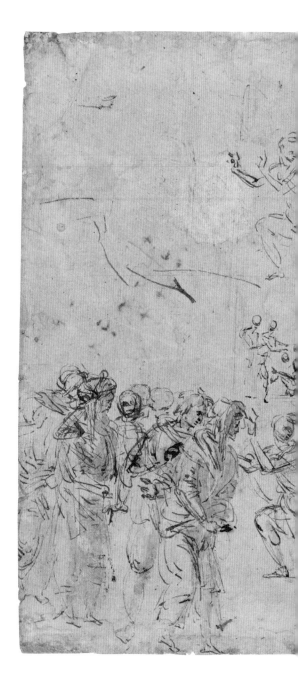

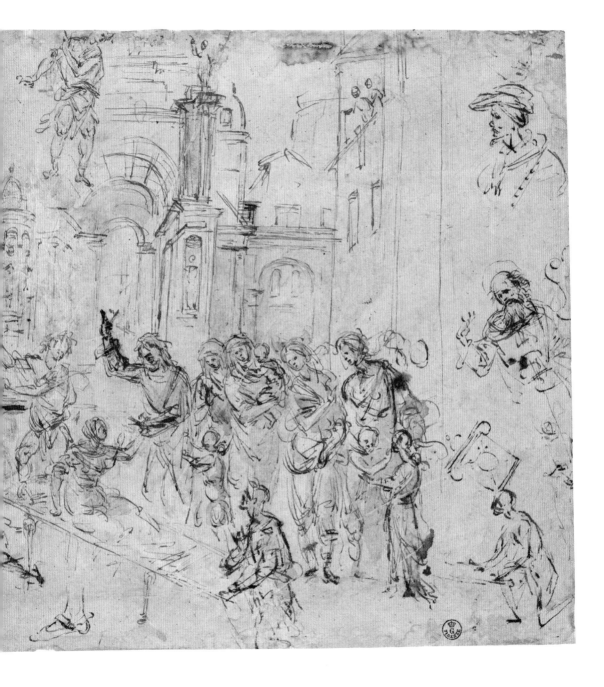

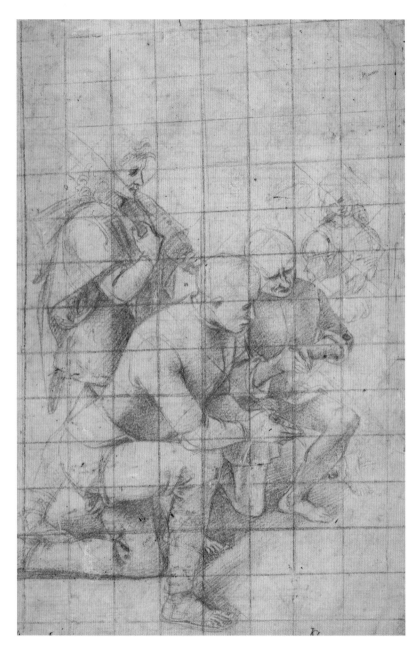

40
LUCA SIGNORELLI
(*c*. 1450–1523)
Three shepherds and an angel
c. 1496
Charcoal, squared in charcoal,
38.4 × 24.8 cm
British Museum, London
(1895,0915 602)

The figures are related to an
altarpiece of the *Adoration of the
Shepherds* now in the National
Gallery, London. The pivotal
figure of the kneeling Virgin is not
shown in this drawing, but it's safe
to assume that Signorelli would
have made a compositional study
of the whole group. The squaring
over the figures in this drawing
was to allow them to be copied
to a larger scale grid drawn on a
cartoon (a full-size drawing), or
on the panel itself.

41
ANDREA SOLARIO
(c. 1465–1524)
Lamentation
c. 1507–9
Pen and brown (two shades)
and some grey ink, with
grey and brown wash,
over black chalk, on paper
washed light brown,
18.9 × 18.6 cm
British Museum, London
(1895,0915.771)

This is a study made by the
Milanese artist while he
was working in France for
Cardinal d'Amboise. The
related painting is in the
Louvre, Paris. The drawing
shows the moment when
the dead Christ has been
taken down from the
Cross – the agitated
gestures and expressions
of grief convey the extreme
anguish of the mourners.

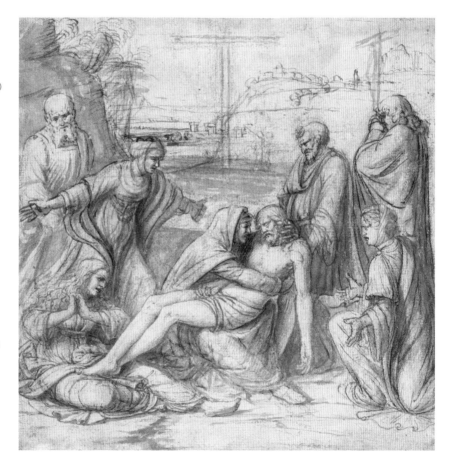

Artists' patrons often wished to be kept abreast as to the design of
their works, and drawings were an ideal conduit for this exchange.
The pictorial quality of the drawing by the Milanese Andrea Solario
(fig. 41) suggests that it was done for this purpose. Another graphic
development was the creation of albums of finished drawings, one of
the most ambitious of which was a world history devised in the 1470s
by a group of Florentine goldsmiths, the *Florentine Picture Chronicle*
(fig. 42). The drawing depicts the death of the Greek playwright
Aeschylus, who tried by living outside to escape the prophecy that he
would be killed by a house falling on his head. He could not escape his
fate as a tortoise, an animal with its own house on its back, accidently
dropped by an eagle ended his life.

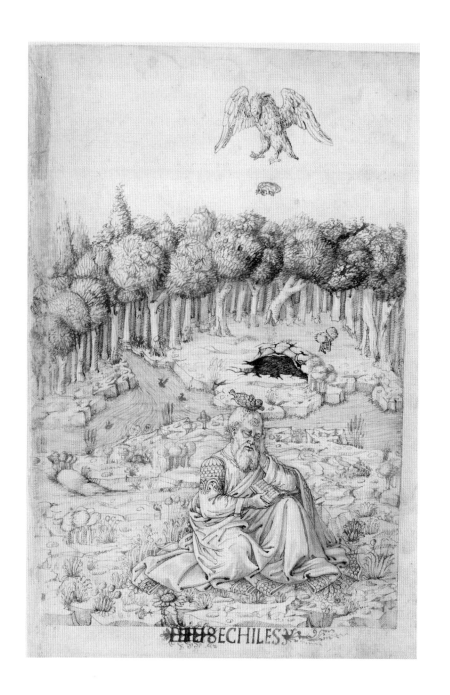

ECHILES

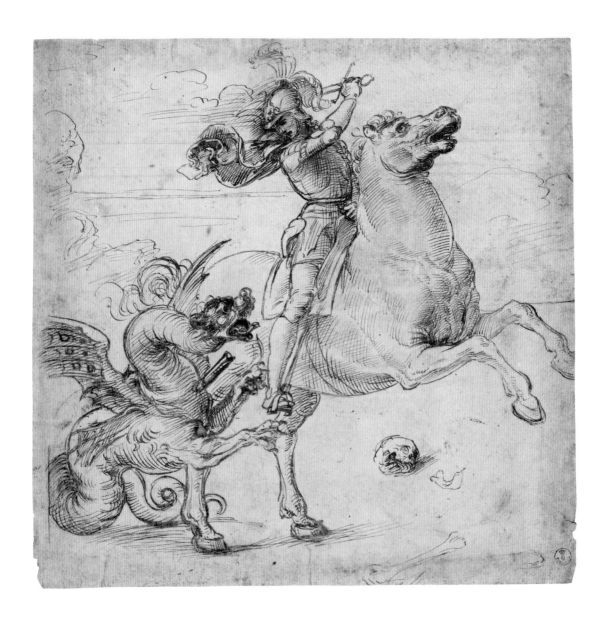

43
RAPHAEL (1483–1520)
Cartoon for St George
c. 1504–5
Pen and brown ink over
traces of black chalk, the contours
of the figures pricked out for
transfer, 26.5 × 26.7 cm
Gabinetto Disegni e Stampe
degli Uffizi, Florence (530 E)

The unparalleled skill of the Urbino-born painter Raphael in finding visual means to communicate narratives of great subtlety and emotional depth was apparent from an early age. In his cartoon (fig. 43), a 1:1 scale blueprint for his *St George* painted around 1504 and now in the Louvre, Paris, he contrasted the calm resolve of the saint with the panic of his horse, the rearing pose of which is inspired by the classical *Horse tamers* located on the Quirinal Hill in Rome (see fig. 19, p. 37). There is no documentary evidence that Raphael went to Rome at such an early date, although his confident quotation of the marble in the study suggests that he had studied it at first-hand rather than via a drawing like Gozzoli's. The complex drama of *The Entombment* drawn about four years later is testament to Raphael's intense study of Leonardo and Michelangelo's work in Florence (fig. 44).

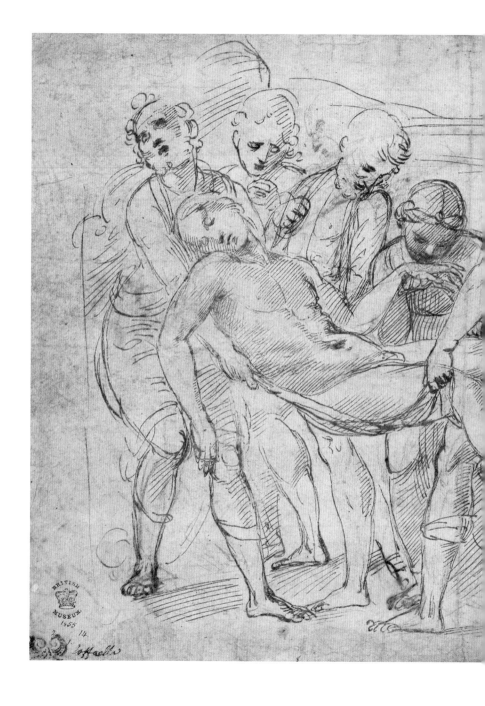

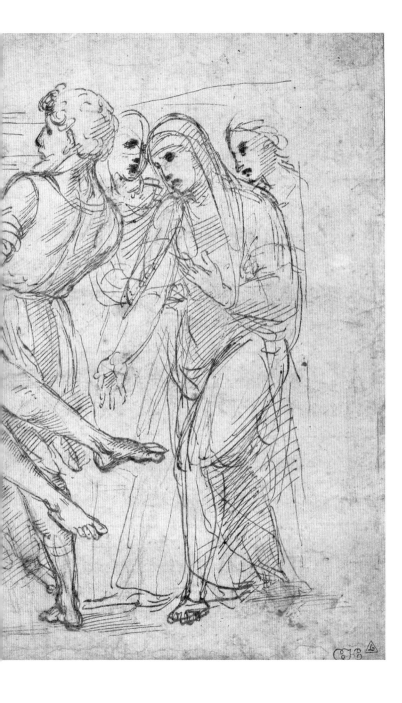

44
RAPHAEL (1483–1520)
The Entombment
c. 1506
Pen and brown ink,
over black chalk and stylus,
22.8 × 31.8 cm
British Museum, London
(1855,0214.1)

A study for the painting commissioned by a Perugian noblewoman,
Atalanta Baglioni, for a funerary
chapel in S. Francesco, Perugia.
The chapel contained the tomb of
the patron's murdered son, so the
pathos of Raphael's treatment of
the Virgin mourning her dead son
had an added poignancy. For a
later drawing for the same work,
see fig. 14, p.28.

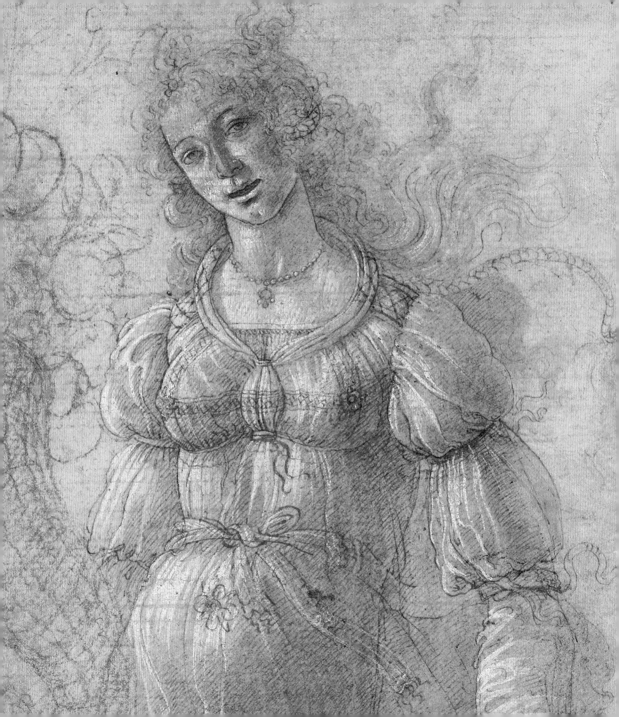

THE NATURAL WORLD

Painting embraces and contains within itself
all things produced by nature or whatever results
from man's passing actions.

LEONARDO DA VINCI
Notes from his unfinished treatise on painting

THE NOTION THAT ARTISTS should be guided by nature is
a recurrent one in contemporary writings about art by practitioners,
such as Leonardo, and by intellectuals like Alberti. Renaissance art
was progressively more naturalistic, a trend that required artists to
analyse their surroundings more closely in drawings.

Two natural history studies from north Italy chart this progression:
a cheetah in watercolour and bodycolour from around 1410 (fig. 45);
and a study of a dead partridge in watercolour from around 1504
by Jacopo de' Barbari (fig. 46). The first comes from a model book,
a storehouse of motifs assembled by copying, while de' Barbari's
springs from direct study. De' Barbari's choice of watercolour and
the level of detail in his drawings were inspired by his friendship with
Albrecht Dürer (1471–1528). The German artist first met de' Barbari
on his visit to Venice and their friendship was renewed when the
Italian came to work in Nuremberg.

Detail of Botticelli's **Allegory of**
Abundance or Autumn (fig. 51, p. 94)

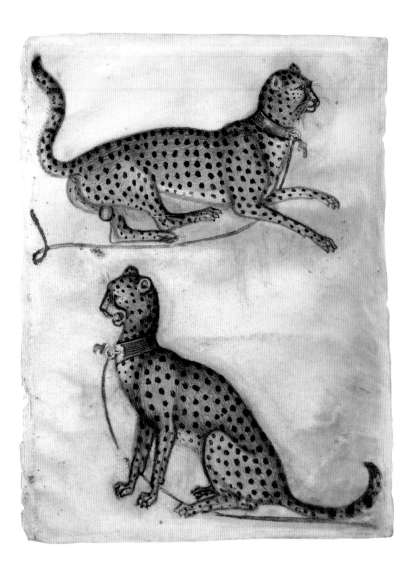

45
Follower of
GIOVANNINO DE' GRASSI
(active 1380s–98)
**Two studies of a cheetah
with a blue collar and leash**
c. 1400–1410
Watercolour and bodycolour
on vellum, 16.4 × 12.3 cm
British Museum, London
(1895,1214.94)

The use of hard-wearing vellum
is typical of drawings made for
model books, collections of useful
motifs to be inserted into paintings
and manuscripts. Drawings of
animals were a favoured subject
in such compendiums because
they did not become outmoded,
unlike figure studies where
changes of costumes rendered
them redundant. Cheetahs are
known to have been kept in
courtly menageries in north Italy,
although the present studies
were more likely copied from
another drawing.

46

JACOPO DE' BARBARI

(*c.* 1460/70–1516)

A dead grey partridge

c. 1504

Brush and watercolour,

25.7 × 15.2 cm

British Museum, London

(SL,5264.23)

This remarkably detailed study
was probably used as the basis for
the earliest pure still-life painiting
in Europe: *Still-life with a dead
partridge* by de' Barbari, an oil on
panel dated 1504 in the Alte
Pinakothek, Munich. De' Barbari's
career was largely spent in northern
Europe, initially in Germany and
then in the Low Countries. His
mastery of watercolour shows his
close scrutiny of drawings in the
same medium by Albrecht Dürer,
like the *Hare* of 1502, now in the
Albertina, Vienna.

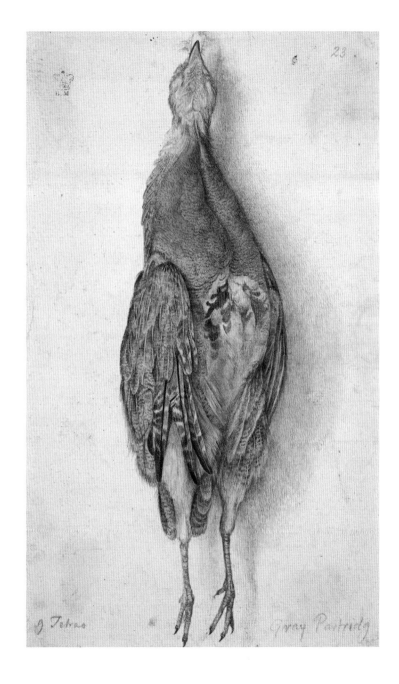

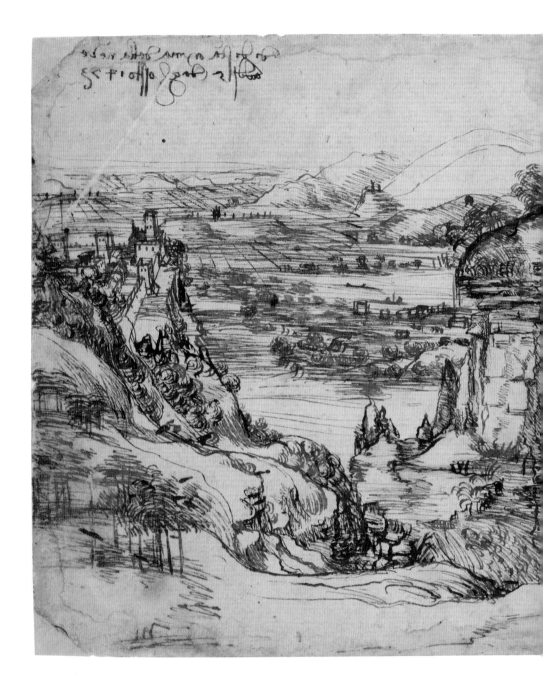

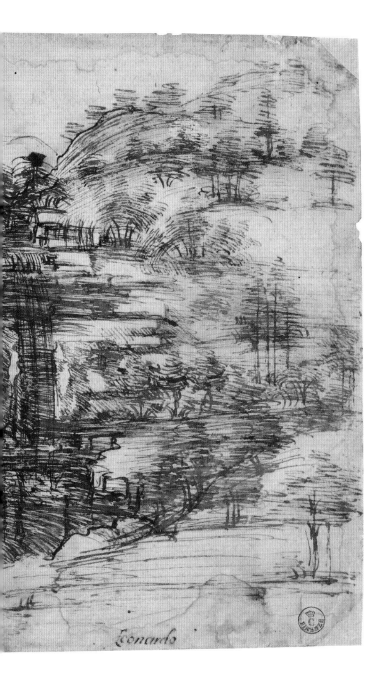

47

LEONARDO DA VINCI
(1452–1519)
Landscape
1473
Pen and two shades of brown ink,
19.4 × 28.5 cm
Gabinetto Disegni e Stampe
degli Uffizi, Florence (8 P)

The inscription in the top left corner, written by the left-handed Leonardo in his habitual right-to-left orientated writing, records that the 21-year-old artist drew it on 5 August 1473. It is unclear why he chose to date it with such precision, but it was perhaps his pride in evolving a graphic short-hand that allowed him to describe so successfully the variety of natural forms, and to evoke the light and atmosphere of a searingly hot August day. The view depicted is likely a mixture of the real and the imagined based on his memory of his childhood home in Vinci, a town in Tuscany that overlooks the Arno valley.

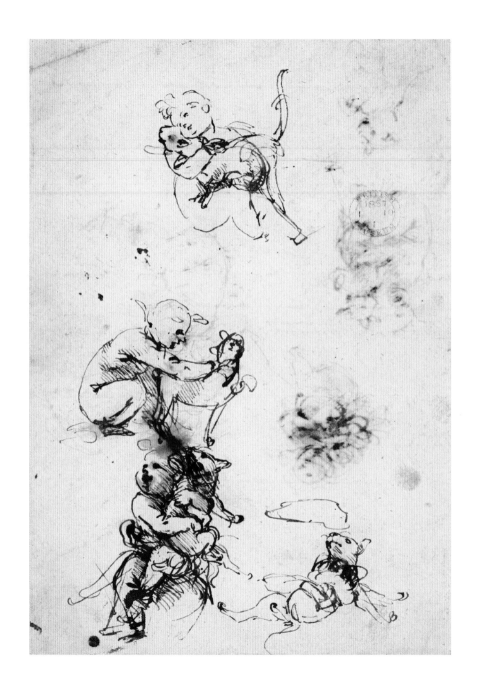

LEONARDO DA VINCI
(1452–1519)
**Studies of the Infant Christ
and a cat**
c. 1478–81
Pen and brown ink, over leadpoint,
21.2 × 14.8 cm
British Museum, London
(1857,0110.1)

Leonardo made a number of
drawings based around the
Infant Christ playing with a cat,
an idea that was never turned
into a painting.

De' Barbari is a rare example of an Italian artist who crossed the
Alps to find employment, but admiration for the realism of northern
European paintings, founded on oil paint, was widespread (see p. 85).
Leonardo's pen evocation of the scenery around his native Vinci is
proof of that esteem (fig. 47). The naturalism of Leonardo's stream
of ideas for the Christ Child playing with a cat (fig. 48) must reflect his
first-hand observation of the interaction between infants and animals.
The cat had no religious symbolism, but unlike the traditional lamb its
unpredicatable behaviour and graceful movement offered a wide range
of possibilities for Leonardo to explore. During his later employment
in the Milan court in the 1480s, Leonardo's natural-history studies
underlie his tortoise-like protection for a wheeled platform bristling
with guns, an ingenious if impractical forerunner to a tank (fig. 49).

49

LEONARDO DA VINCI
(1452–1519)

**Military machines and
a study for a spearhead**

c. 1485
Pen and brown ink, over stylus
(some drawn with a ruler or
a compass), 17.3 × 24.6 cm
British Museum, London
(1860,0616.99)

Leonardo advertised his skill as
a weapons designer to Ludovico
Sforza, the Duke of Milan, when
he joined the Milanese court in the
early 1480s. The Florentine artist
was doubtless mindful that his
patron was a celebrated
military commander and that the
fabrication of arms and armour
was a major industry in Milan.
In his notes accompanying these
studies, he observed the need for
the scythes in the upper study to
be raised while passing through
friendly ranks. In the covered
vehicle, drawn with and without
its protective shell below,
Leonardo wrote that it would
need eight men to propel it
across the battlefield.

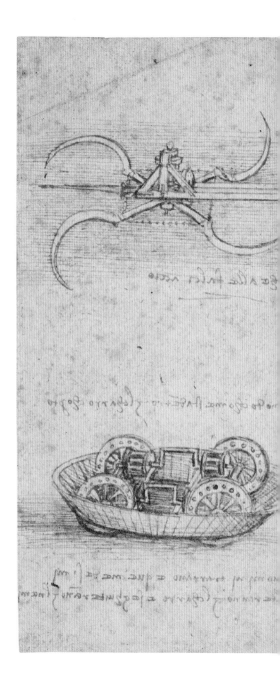

50
JACOPO BELLINI
(*c.* 1400–70/1)
Winged lion ridden by a satyr
from an album of 99 folios
c. 1455–60
Leadpoint, 41.5 × 33.6 cm,
each page
British Museum, London
(1855,0811.52)

The naturalism of Renaissance art should not be overstated as observed detail and fantasy were often mixed together, such as in the leadpoint drawing of a winged lion ridden by a satyr by the Venetian painter Jacopo Bellini (fig. 50), father of Gentile, in his album of leadpoint drawings. As with the album of his younger contemporary Marco Zoppo, fantastical inventions such as this one were designed to showcase the inventive talent of Jacopo and spark the imagination of the viewer. The Venetian's beguiling combination of the real and the imagined is also found in the allegorical figure of Abundance by the Florentine Sandro Botticelli (fig. 51), although the artistic effect is very different. The figure's attenuated limbs glimpsed beneath diaphanous, fluttering drapery, present an abstracted, yet compelling ideal of feminine grace.

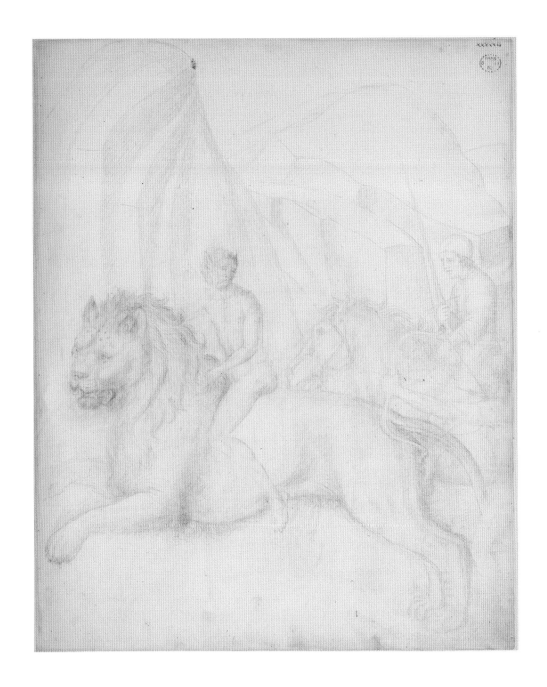

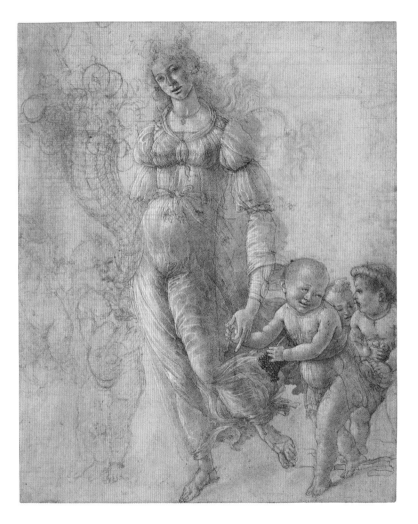

51
ALESSANDRO FILIPEPI,
called SANDRO BOTTICELLI
(1444/5–1510)
**Allegory of Abundance
or Autumn**
c. 1480–5
Black and red chalk, pen and
brown ink, brown wash,
heightened with lead white, on
paper with a irregular orange-red
ground, 31.7 × 25.2 cm
British Museum, London
(1895,0915.447)

The elongated grace and sensuality
of the central figure is similar to
that found in Botticelli's contem-
porary paintings, such as the *Birth
of Venus* and the *Primavera* in
the Galleria degli Uffizi, Florence.
The function of this elaborately,
if unevenly finished drawing is
unclear, but it is perhaps most
likely an abandoned demonstratiion
or presentation piece designed as
a work of art in its own right.

SUGGESTED READING

GENERAL

Ames-Lewis, F., *Drawing in Early Renaissance Italy*, 2nd edn, New Haven and London, 2000.

Alberti, L.B., *On Painting*, trans. C. Grayson, London, 1991.

Berenson, B., *The Drawings of the Florentine Painters*, 3 vols, Chicago, 1938.

Cennini, C., *The Craftsman's Handbook*, trans. D. V. Thompson, Jr., New Haven, 1933.

Elen, A.J., *Italian Late-Medieval and Renaissance Drawing-Books*, Leyden, 1995.

James, C., Corrigan, C., Enshaian, M.C., et al., *Old Master Prints and Drawings: A Guide to Preservation and Conservation*, trans. M. B. Cohen, Amsterdam, 1997.

Meder, J., *The Mastery of Drawing*, trans. and rev. W. Ames, 2 vols, New York, 1978.

Richter, C. (ed.), *A Selection from the Notebooks of Leonardo da Vinci*, Oxford, 1977.

Vasari, G., *Lives of the Painters, Sculptors and Architects*, 2 vols, trans. G. du C. Vere with an introduction by D. Ekserdjian, London, 1996.

Watrous, J., *The Craft of Old Master Drawings*, Madison, 1967, repr. 2006.

BRITISH MUSEUM CATALOGUES

Chapman, H., Faietti, M., *Fra Angelico to Leonardo, Italian Renaissance Drawings*, exhibition catalogue, British Museum, London, 2010.

Popham, A.E. and Pouncey, P., *Italian Drawings in the Department of Prints and Drawings in the British Museum: The Fourteenth and Fifteenth Centuries*, 2 vols, London, 1950.

Turner, N., *Florentine Drawings of the Sixteenth Century*, exhibition catalogue, British Museum, London, 1986.

JACOPO BELLINI

Eisler, C., *The Genius of Jacopo Bellini: The Complete Paintings and Drawings*, New York and London, 1989.

LEONARDO DA VINCI

Bambach, C.C. (ed.), *Leonardo da Vinci, Master Draughtsman*, exh. cat., Metropolitan Museum of Art, New York, 2003.

Popham, A.E., *The Drawings of Leonardo da Vinci*, rev. edn with an introduction by M. Kemp, 1994.

MICHELANGELO

Chapman, H., *Michelangelo Drawings: Closer to the Master*, exh. cat., British Museum, London, 2006.

RAPHAEL SANZIO

Jones, R., and Penny, N., *Raphael*, New Haven and London, 1983.

GLOSSARY

Bodycolour
Opaque paint made up of pigment, white lead and a binder.

Chalk (*black, red and white*)
Naturally occurring stone that was quarried and cut into sticks.

Charcoal
Thin sticks of wood carbonized by being placed in an air tight container in hot ashes.

Ink
Made from mixture of iron sulphate and tannins extracted from oak galls, the resulting iron-gall ink was originally black.

Lead white
Opaque pigment made from carbonate of lead applied with a brush as a highlight.

Metalpoint
Most commonly a thin stick of silver or silver mixed with tin (hence silverpoint) that left a deposit on a prepared surface. Lead could also be used which was softer and could be drawn on untreated paper.

Paper
Made from fibres obtained from rags and ropes, which required a gluey preparation to be impervious to ink.

Pen
Sharpened feathers from birds such as geese.

Prepared paper
Silverpoint required a surface with a slightly roughened surface made from powdered bone and lead white, such preparations were often coloured.

Silverpoint
See Metalpoint

Stylus
A stick of hard metal capable of scoring the paper with its sharpened end.

Vellum
Treated sheep and goat skins, expensive but durable.

Wash
Diluted ink applied to paper with a brush.

Watercolour
Pigment dissolved in water to produce a translucent, coloured wash.

PICTURE ACKNOWLEDGEMENTS

All photographs are © The Trustees of the British Museum, Department of Prints and Drawings or © Gabinetto Disegni e Stampe degli Uffizi, Florence as indicated in each caption, and courtesy of the Department of Photography and Imaging at the British Museum.

All works illustrated are rectos unless otherwise stated.